LIMERICK

SHARON SLATER

The
History
Press
Ireland

This book is dedicated to my brother Conrad
(1981-2016), who would have enjoyed this book
and the pictures within, and my dear aunt Wendy
Jewell (1956–2015), who was unwavering in her
love and support. Your memories will live on forever.

First published 2016

The History Press Ireland
50 City Quay
Dublin 2
Ireland
www.thehistorypress.ie

The History Press Ireland is a member of Publishing Ireland,
the Irish book publishers' association.

© Sharon Slater, 2016

The right of Sharon Slater to be identified as the Author
of this work has been asserted in accordance with the
Copyright, Designs and Patents Act 1988.

British Library Cataloguing in Publication Data.
A catalogue record for this book is available from the British Library.

ISBN 978 1 84588 898 5

Typesetting and origination by The History Press
Printed and bound by TJ Books Ltd

CONTENTS

ACKNOWLEDGEMENTS

This publication would not have been possible without the kindness and generosity of the following individuals and institutions, in no particular order:

Sean Curtin, David and Steve Ludlow, The Jesuit Archives, Eugene Barry, Jacqui Hayes, Limerick Archives, Brian Hodkinson, Limerick Museum, *Limerick Leader*, Ann Kirby, St Munchin's College, Brian O'Donoghue, Conrad and Catherine Slater, Anne O'Brien, Scoil Íde, David Bracken, Limerick Diocesan Office, Thomas Hayes, Reg Morrow, Yvonne Thompson, Helen Downing, National Library of Ireland (NLI), Dan Troy, Martin Kiely, Sarah Lee Kiely, Emily Kearns, the Greaney family from Rossa Villas Garryowen, David Zelz, Ger Hayes, the Russell family, Mike Cowhey, Ray Howard and my family Susan, Stephen and Peter.

1

BANDS AND FAMOUS PEOPLE

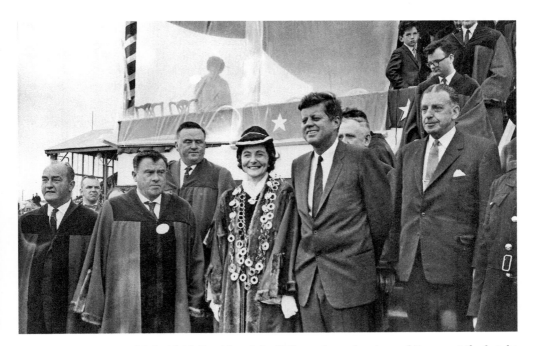

From 22 June to 2 July 1963, President John F. Kennedy made a tour of Europe at the height of the Cold War, the most famous episode of which was his famous 'Ich bin ein Berliner' speech in West Berlin on 26 June. On the same day, he arrived in Dublin at the beginning of a three-day visit to Ireland, the first ever made to this country by a serving US President. Mrs Kennedy did not accompany him as she was expecting a baby. A gift of a Limerick Lace christening robe was presented to the President in Limerick. (Courtesy of Limerick Archives)

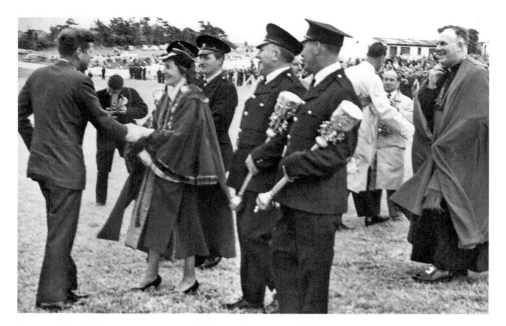

Frances Condell was a most remarkable Irish woman of her time – she was the first female Mayor of Limerick, a member of the Church of Ireland and a cultured, distinguished lady. The original itinerary for the President's tour of Europe did not include a stop in Limerick but on 20 May 1963, Frances wrote to the US Ambassador to Ireland, lobbying for Limerick's inclusion and outlining how 'arrangements for a visit to Limerick can be speedily made'. The mayor would not take no for an answer and President John F. Kennedy stopped briefly and historically in the city. (Courtesy of Limerick Archives)

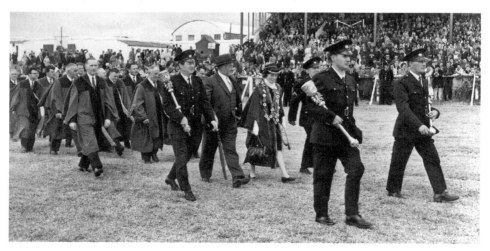

Mayor Condell, flanked by the four macebearers and followed by the city councillors, walking through Greenpark Racecourse. These silver maces have been an integral part of civic ceremony in Limerick since 1739 when the mayor at the time, George Sexton, commissioned their construction. The maces were probably made by Limerick silversmith John Robinson. (Courtesy of Limerick Archives)

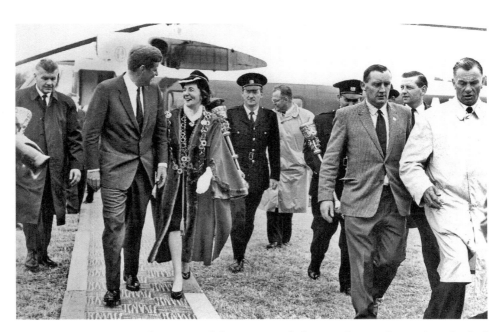

President Kennedy arrived in Limerick by US Army helicopter from Galway where he had given a speech in Eyre Square. For such a momentous occasion, President Kennedy's visit to Limerick was remarkably brief, lasting for only half an hour. He arrived in Greenpark Racecourse Limerick at around 1 p.m., accompanied by some of his entourage and Taoiseach Sean Lemass, and was greeted by Mayor Condell. He received a warm welcome from the large and ecstatic crowd waiting to greet the first American President to visit Limerick. (Courtesy of Limerick Archives)

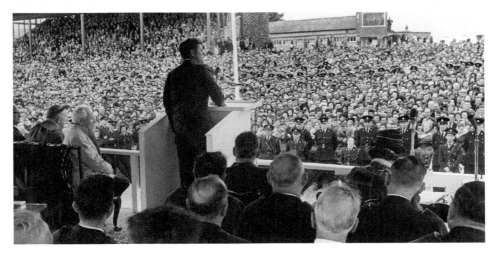

Greenpark was a horse-racing venue in County Limerick, Ireland. At the venue in 1979, Irish runner John Treacy won gold at the IAAF World Cross Country Championships. John Treacy was nicknamed 'The Mudlark', due to his winning consecutive world cross-country championships in muddy conditions. The course closed in 1999 after 130 years of racing. (Courtesy of Limerick Archives)

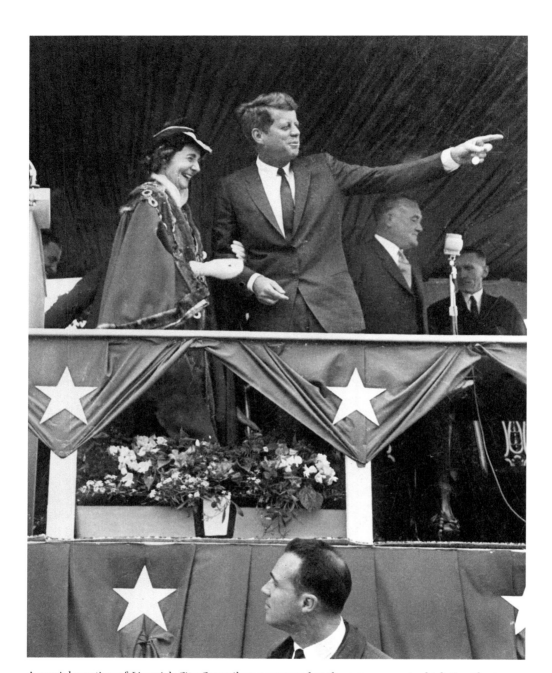

A special meeting of Limerick City Council was convened at the racecourse at which President Kennedy was conferred with the Honorary Freedom of Limerick. After a silent prayer, roll call and reading of the minutes of the meeting at which it had been decided to confer the Freedom, Mrs Condell greeted the President in a celebrated address that Kennedy described as 'the best speech that I have heard since I came to Europe'. Then Mr T.P. McDermott, Limerick City Manager, read the Certificate of Freedom, which Mayor Condell handed the President, declaring him to be a Freeman of Limerick. (Courtesy of Limerick Archives)

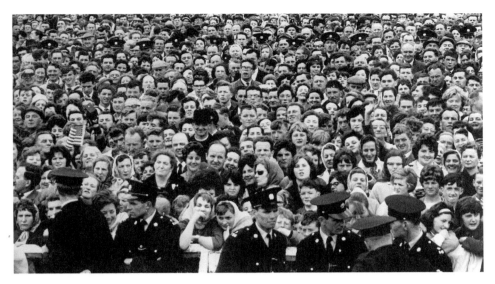

An enormous crowd was in attendance to catch a glimpse of the President. On 1 October 1979 Pope John Paul II also visited Greenpark Racecourse and over 400,000 people turned out to view the pontiff deliver mass. 'Here in Limerick, I am in a largely rural area and many of you are people of the land. I feel at home with you as I did with the rural and mountain people of my native Poland and I repeat here to you what I told them. "Love the land; love the work of the fields for it keeps you close to God, the Creator in a special way".' (Courtesy of Limerick Archives)

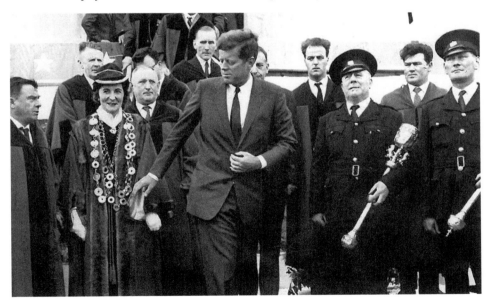

At 1.30 p.m., the President left Limerick for Shannon Airport from where he flew to London to continue his European tour. He promised to return to Ireland but was assassinated five months later in Dallas, Texas. Prior to President Kennedy's arrival in Limerick on 29 June 1963, street vendors did a roaring trade selling Irish and American flags for a shilling apiece. (Courtesy of Limerick Archives)

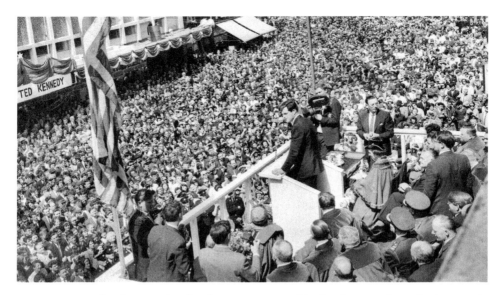

In May 1964, only a few months after the assassination of his brother President John F. Kennedy, Edward 'Ted' Kennedy visited Limerick. He arrived at Cruise's Hotel, O'Connell Street and took to the balcony overlooking the enormous crowd. Here he thanked the Irish people for their support and prayers during the family's difficult time. Frances Condell was still in office as mayor at the time and wore a new hat for the occasion. Both this hat and the hat worn during the visit of John F. Kennedy are held in the Limerick Museum. (Courtesy of Sean Curtin)

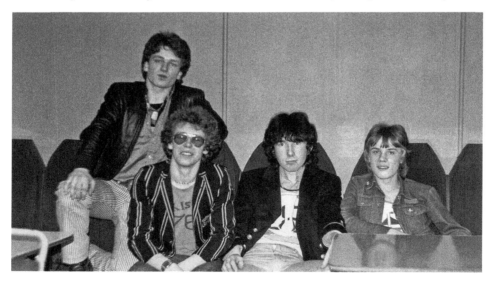

On St Patrick's week 1978 Limerick held a 'Limerick Civic Week Pop '78 Competition' in the Stella Ballroom on Shannon Street. A little-known Dublin band The Hype was to take part. At the last minute before going on stage they changed their name to U2. This marked the first time the band appeared under the name of U2. They went on to win a prize of £500 and the promise of a record deal. It was a pivotal moment for the band and Larry has commented that '... We had no real idea how winning in Limerick would change our lives'. (Author's Collection)

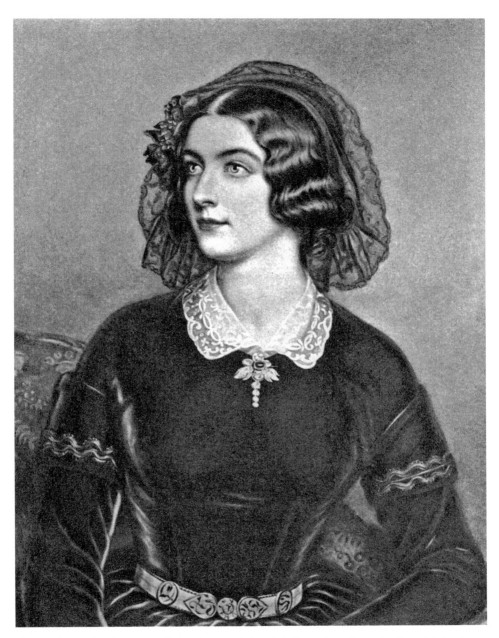

Eliza Gilbert, also known as Lola Montez, claimed to have been born in Limerick in 1818. She was actually born in Sligo in 1821. When she was only a young woman in her early twenties she was involved in an international controversy following a well-publicised affair with the elderly King Ludwig I of Bavaria. The affair caused the king's downfall and he was forced to abdicate his crown and Lola had to leave the country. Later she was tried for bigamy, raised pet grizzly bears and publicly whipped one of her critics in Australia. In 1858 she stopped in Limerick, speaking at the Theatre Royal and staying at Cruise's Hotel. (Painting by Joseph Karl Stieler, *c.* 1847)

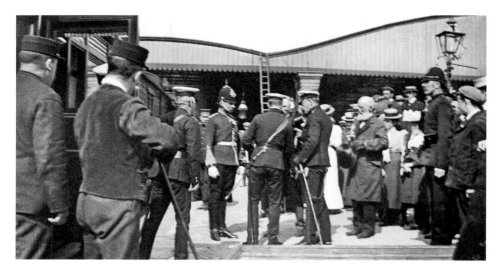

In August 1900 Prince Arthur, Duke of Connaught, the seventh child and third son of Queen Victoria and Prince Albert, arrived at Limerick railway station. As Commander of the Forces in Ireland he visited Limerick to inspect the garrison. The prince arrived by train from Cork having only given one day's noticed. His arrival was met with the expected pomp and ceremony, led by Thomas Henry Cleeve (shaking the prince's hand in this image) of Cleeve's Condensed Milk Factory. His wife, Phoebe Cleeve, is also on the platform. The Prince stayed in the city for lunch before leaving for Dublin. (Courtesy of the Ludlow family)

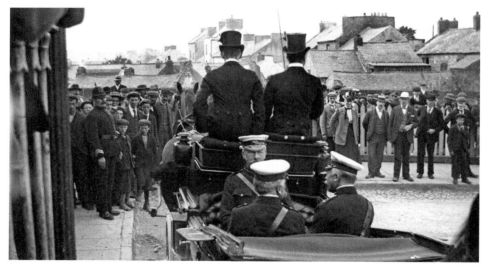

Price Arthur in his carriage, in the background you can see the roofs of the houses in the narrow laneways off Carey's Road. These were one of the poorest and most over-populated areas in the city. This was demolished during the slum clearings of the 1950s. Carey's Road had the highest number of men enlisting in the army during the First World War; many of them joined the Royal Munster Fusiliers. Some of the lanes were King's Lane, Young's Lane, Richardson's Lane, Sparling's Lane, the Quarry Boreen, Anderson's Court, Pump Lane, Walsh's Lane, Punch's Lane, Lee's Lane, Donnelly's Lane and Glover's Lane. (Courtesy of the Ludlow family)

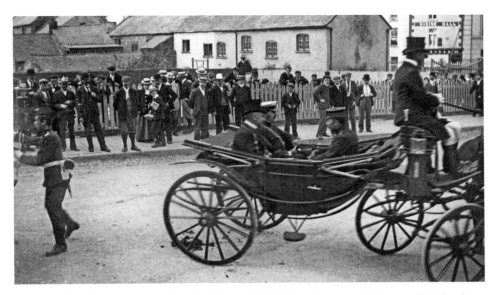

Prince Arthur, leaving the station. On 20 April 1885 the Prince and Princess of Wales (later King Edward VII and Queen Alexandra), accompanied by their eldest son Prince Albert Victor, arrived in Limerick city by train from Killarney. However, as had been planned, they did not leave the railway station. Despite considerable 'groaning and hissing' from nationalist crowds assembled along the track as their train approached the station, the Royal party were warmly greeted by around 5,000 people on the platform. Straw hats were a common fashion item at the time for both men and women. (Courtesy of the Ludlow family)

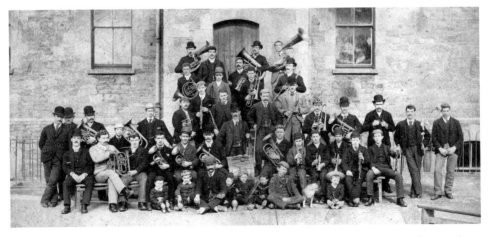

The Victuallers Band formed in 1865 and are in fact still around, though now known by a different name. Included in this picture of the old Victuallers' Band are Jim Greaney, Connie Sheehan, Ned Wallace, Jack Wallace, Bobby O'Dwyer, Paddy Lillis, Pa Hogan, Steve Collins, Paddy Collins, Paddy Sexton, John Greaney and Tim Quane. After they disbanded in 1897 they changed their name first to St John's Temperance Band (based in the Temperance Hall, Mulgrave Street), then St John's Working Men's Band and today to St John's Brass & Reed Band. (Courtesy of the Greaney family from Rossa Villas, Garryowen)

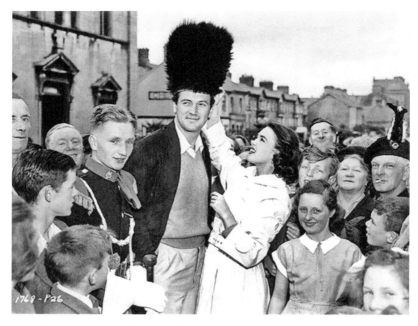

On 14 June 1954 Hollywood film actors Rock Hudson and Barbara Rush flew into Shannon Airport on their way to Dublin for the filming of 'Captain Lightfoot'. The pair spent the day in Limerick and the night in Cruise's Hotel after attending a dance for the Crescent Rugby Football Club. Hudson would later say the dance was 'faster paced then anything we know back home'. While in Limerick they watched the Limerick Pipe Band outside St Joseph's church on O'Connell Avenue. The band was parading with the Knights of Malta along O'Connell Street. Hudson proceeded to attempt to play with the band, much to the delight of onlookers. (Courtesy of Universal Pictures)

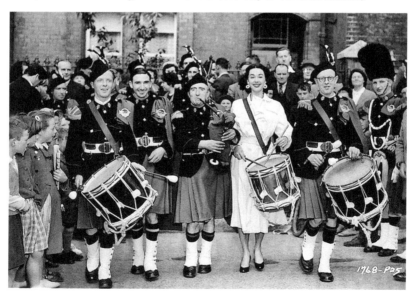

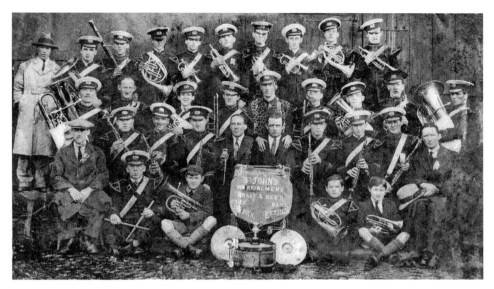

In 1926 St John's Band Working Men's Brass & Reed was founded. The bandmasters over the first forty years were Frank Imbush, J. O'Shaughnessy, Jack Patterson, Ned Moloney, Albert Kersley, Jim Moane, Stephen Collins, M. Doyle and William Ferguson. They played at the principal GAA matches. From 1939 to 1945 the instruments were set aside, with many of the players joining the Irish Guards. The band was based in St John's Pavilion in Mulgrave Street until 2011 when they relocated to a purpose-built site on Garryowen Road. (Courtesy of Ray Howard)

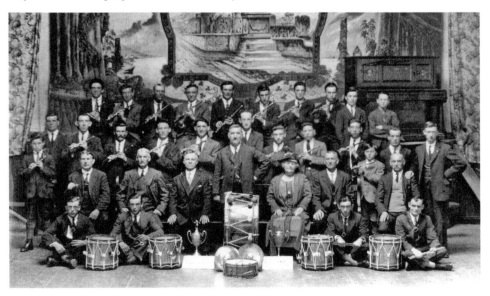

The home of the St Mary's Fife and Drum Band was locally known as 'Todsie's' on Mary Street. It was so named after Patrick 'Todsie' McNamara (standing in front centre), a member of the Abbey Fishermen guild. The hall was also used as a social club with snooker tables. Gerry 'Riley' Clancy, the nephew of 'Todsie', was the caretaker for many years. The hall is now rented out to the local Irish-speaking primary school. (Author's Collection)

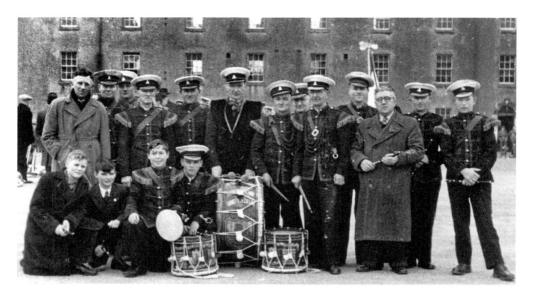

In the autumn of 1885, St Mary's Fife and Drum Band was founded. From its humble beginnings in the Yellow Driller on the Kings Island, it progressed next to Nicholas Street then on to Barrington's Mall, Fish Lane and finally in 1922 the new band room was built in Mary Street with financial aid from the band's American Committee. In 1963 the band had the honour of playing for both President John Fitzgerald Kennedy during his visit to Limerick and for Pope John Paul II during the papal visit to Limerick. (Author's Collection)

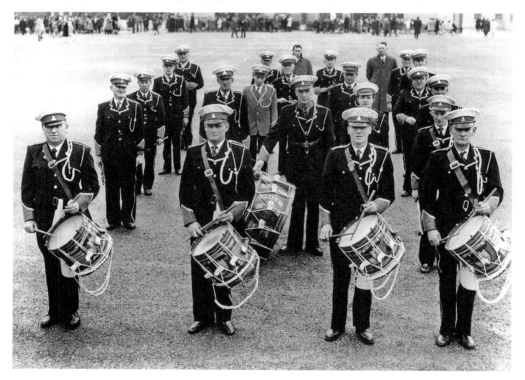

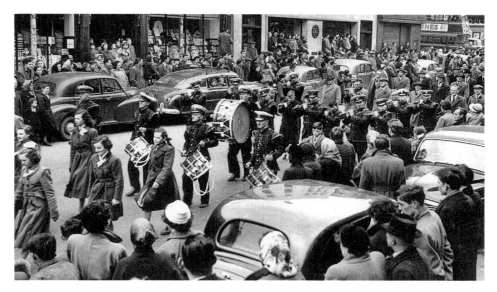

The musical talent of the St Mary's Fife and Drum Band must have been unique; at its first attempt, in September 1885, the band won the All-Ireland Championship under the baton of maestro Steve Collins. The band line-up on that occasion was J. Hayes, J. McNamara, J. Ring, J. Sullivan, T. Forward, J. Gogarty, J. Donoghue, P. McNamara (Bandmaster) J. O'Donovan and J. Salmon. The band won the All-Ireland Championship for flute and drum bands twelve times between 1885 and 1947, as well as the Republic of Ireland Championship in 1963, 1964, 1975, 1986 and 1988. (Author's Collection)

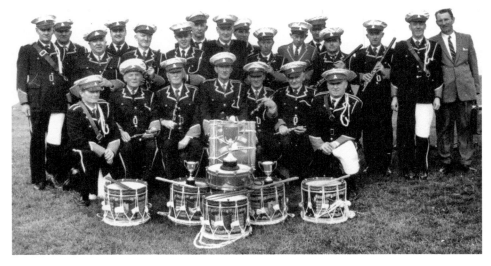

The First World War saw the involvement of members of the band and the death of three of them: Michael Davis, John McNamara and Joseph Salmon (son of the band conductor, Patsy Salmon). All three were members of the Royal Munster Fusiliers and all three were killed in action within six months of each other in 1915. One of the band's drums was on display in the Limerick Museum and Archives 'Stand Up and Fight' exhibition, which remembered Limerick in the First World War and ran throughout 2015. (Author's Collection)

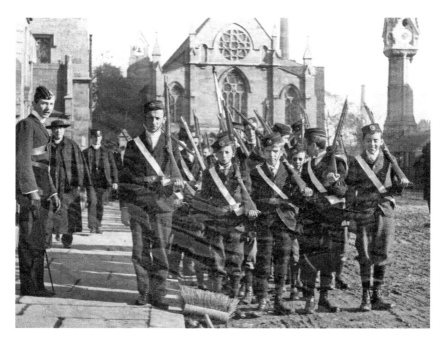

The Church Lads' Brigade is an Anglican Church youth organisation founded by Walter Gee in 1891 London. It was founded to attract youngsters who might be starting work and had drifted away from Sunday school in order to give them a purposeful recreational and social life. The Lads were disciplined in rifle drills and various military-style exercises. There are branches in England, Ireland, Bermuda, Kenya, South Africa, Newfoundland and St Helena. (Courtesy of the Ludlow family)

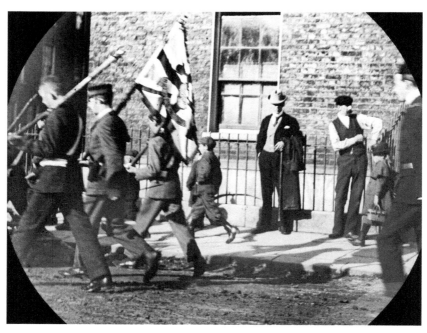

2

SPORTS AND SOCIAL

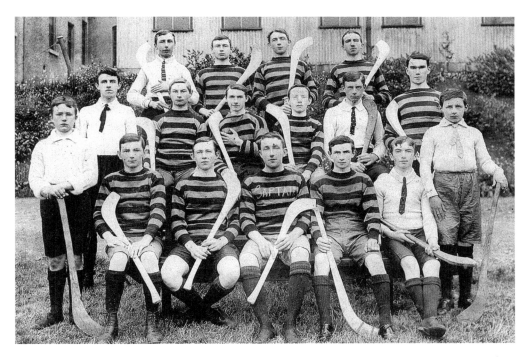

The St Munchin's College Hurling Team, 1907. From left to right, back row: P. Hickey, M. O'Sullivan, J. Leo, G. Dillon. Centre row: R. McCarthy, T. Mortell, C. O'Sullivan, R. O'Brien, E. Irwin, M. Twomey. Front row: P. Coll, J. Carroll, P. O'Brien, D. Boohan, P. O'Neill, P. Feely, T. Culhane. (Courtesy of St Munchin's College)

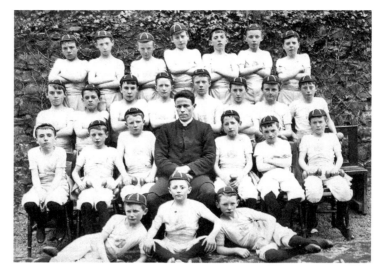

Sacred Heart College, Crescent dumb-bell group, 1903. From left to right, back row: Paddy Carmody, Paddy Grimes, St John Dundon, Cecil Kenny, Alf Gavin, Paddy Byrnes, Robert Frost. Second row: Ned Hayes, Michael Fitzgibbon, Frank O'Sullivan, Andy Glynn, Paddy Dundon, Jim Buckley, Eddie King, Chris McGrath. Seated: Vincent Dowling, Eddie Cunningham, Jim O'Sullivan, Mr John Forster SJ, Morty Glynn, Jimmy Gallagher, Dom McCormack. Sitting on ground: Joe Foley, Michael Sheehan, Henry Hardiman. Mr John Forster SJ (1870–1964) taught at the Sacred Heart College, Crescent, Limerick (1901–03) and was yet to be ordained (1906), hence Mr instead of Fr. He was born in Brunswick, Melbourne and returned to Australia after ordination. (Courtesy of the Irish Jesuit Archives)

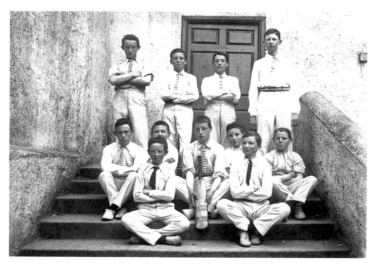

Though Limerick is most famous for her love of rugby, other English sports, such as cricket, were also quite popular. Pictured here is the Sacred Heart College, Crescent cricket team, *c.* 1905. From left to right, back row: Henry Hardiman, Gerard Herriott, Frank Dowling, William Hynes. Middle row: Unnamed, Willie Nolan, Dominick Clune, Tom O'Brien, Francis Clune. Front row: Ginger O'Sullivan, Frank O'Malley. (Courtesy of the Irish Jesuit Archives)

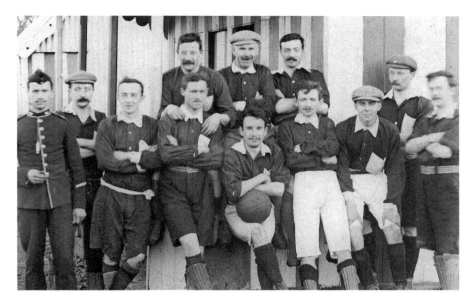

Many of the community groups had their own sports team, which played matches against other local clubs. The Protestant teams were not allowed to train or play sports on a Sunday, which had an impact on their matches. The Protestant Young Men's Association football team are wearing shin guards, though some of the team are holding their shorts up with a length of cloth. John Riddell, presumably the captain of the team, holds the ball. (Courtesy of the Ludlow family)

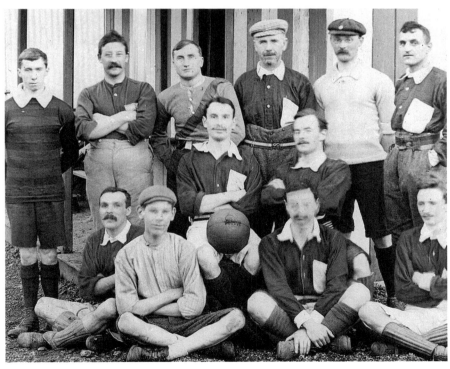

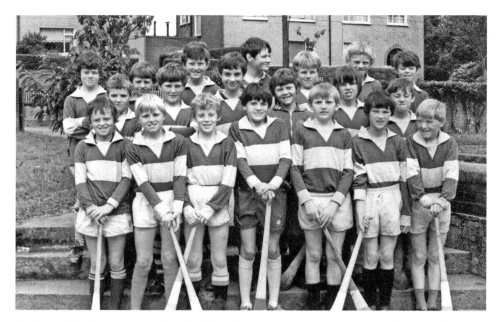

St Munchin's Boys National School hurling teams, posing in front of their school on Shelbourne Road. St Munchin's Boys National School was opened by the Christian Brothers at Hassett's Cross, Thomondgate in 1955. The school closed in 2015 and the remaining pupils were transferred to the Convent Girls Primary School in Ballynanty along with the students of St Leila's National School, Kileely. (Courtesy of Limerick Museum)

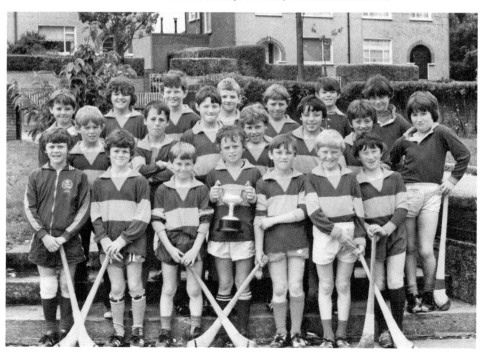

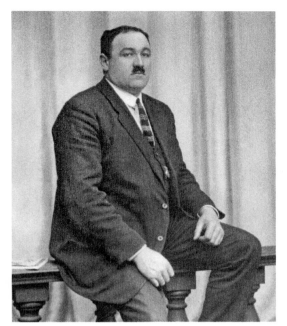

John O'Grady (1892–1934), Olympian. He represented Ireland in the 1924 Summer Olympics and was the country's flag-bearer. He participated in the shot put, which he threw a distance of 12.75 metres, placing him 17th in the Olympics. John stood over 6 feet tall and weighed more than 18 stone, a formidable sight, but all who knew him mentioned his jolly disposition. In his later years, he was the rates book inspector for the Limerick County Council. There is a large stone monument on Mulgrave Street in the shape of a weight to commemorate his achievements. (Author's Collection)

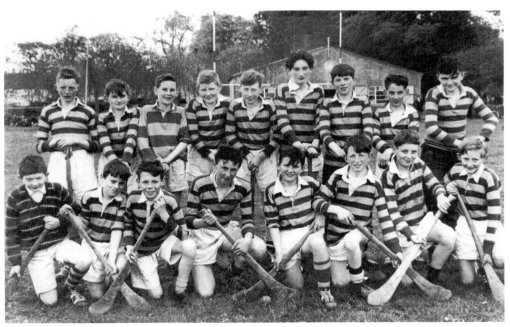

In 1964 all 400 students of the Christian Brothers Secondary School on Sexton Street were involved in hurling. The pitch was located about a mile from the school and the trainer of the senior team was Brother Burke. It was in this school that Limerick's Eamonn Grimes collected the first of his many titles. He won his first Harty Cup medal following a defeat of St Flannan's College in 1964. Grimes was the captain of the All-Ireland winning team in 1973. (Courtesy of Dan Troy)

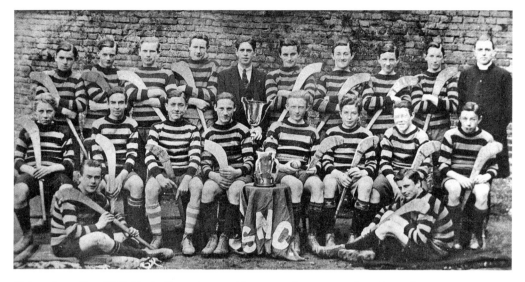

Pictured are the 1922 Harty Cup winners. That year the cup was fraught with controversy. St Munchin's College, Corbally were pronounced winners by default as their opponents, the Presentation Brothers College, Cork, had failed to return the proper paperwork and were disqualified. The Harty Cup is a hurling competition for schools in the province of Munster. Players have to be under the age of 18½ to compete. The first Cup was won by Rockwell College, Cashel in 1918. (Courtesy of St Munchin's College)

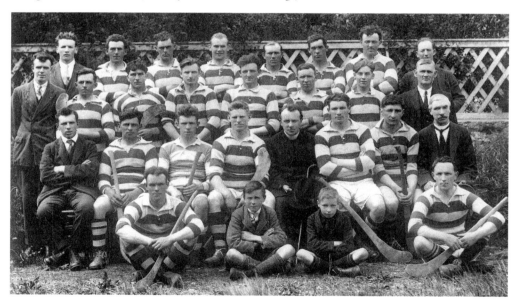

Claughaun GAA Club was founded in 1902. Tradition has it that the club emanated from the Pennywell and Poulin areas of Limerick city, leading to an eternal link with the parish of St John's that is still in evidence today, in spite of the fact that the club now resides on the Childers Road in neighbouring St Brigid's. The team pictured in 1920 included Dan Troy, Feeney Shanny, Thomas Cross, Mike Madden and Paddy Hickey. (Courtesy of Dan Troy)

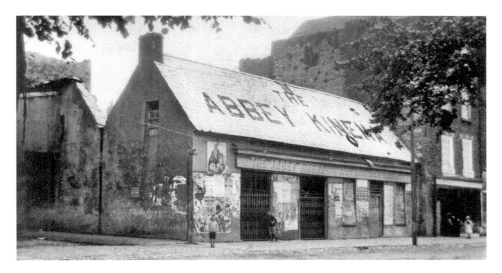

The Abbey Kinema on George's Quay opened in the early 1920s but was destroyed by fire on 12 April 1930. Ironically only a few months earlier fire protection had been put around the projector's box to prevent fire from the film reels. It was thought at the time that the fire was due to a lit cigarette left on the floor after a showing. Following the fire the owner, James J. Trehy, worked as a manager of the Lyric Cinema until ill health caused him to retire and he passed away in October of that year aged 65. (Author's Collection)

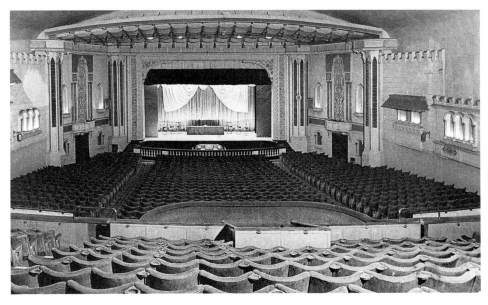

Situated on Bedford Row, this was the site of two cinemas of the same name. The first opened in 1935 with the film *Brewsters Millions*. It closed in 1974 and was demolished in 1988. The second was the most recent of all the cinemas in Limerick. It was built in the early 1990s and abandoned in the early 2000s. Above the cinema was a bowling alley from which the breaks of the skittles could be heard during the film. (Courtesy of Sean Curtin and Mike Cowhey)

Up until the 1980s dancehalls were an integral part of Limerick social life and showbands played at the many venues throughout the city. Earl Connolly was the entertainment columnist with the *Limerick Leader* from 1937 until he retired in 1992 and his reviews were a vital read for the discerning dancer and cinemagoer. (Courtesy of the *Limerick Leader*)

It was not until 20 August 1877 that the park at Pery Square became the public park known as People's Park. The public park was dedicated to the memory of Richard Russell, a prominent local businessman, and was opened by Major Spaight. The main entrance gate includes the memorial inscription to Richard Russell. Prior to this the park was only for the keyholders who were residents of Pery Square Tontine Company. The tontine plan, established in 1938, intended to surround the park with housing for the more affluent members of society but the funds for the project ran out before this could be completed. This picture comes from one of Russell's grand nephews. (Courtesy of the Russell family)

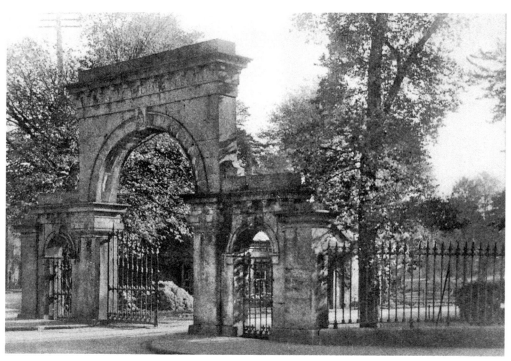

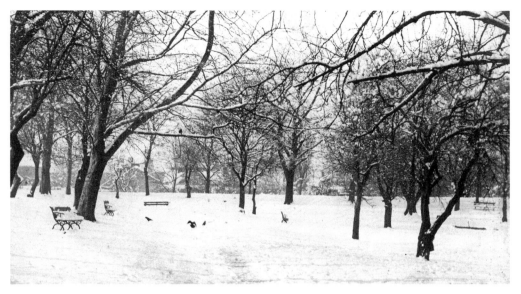

Even on freezing cold days and covered in snow the People's Park was popular with locals. Wrapped up warm, they still enjoyed taking a stroll and some photographs. (Courtesy of the Ludlow family)

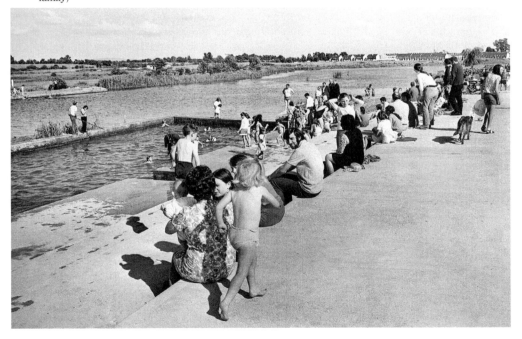

The Corbally Baths were built in 1949 by the city council as a public swimming pool. The caretakers in the 1950s were all married couples, the Hanleys, the Ryans and the Keoghs. It was common for swimmers to go to the pool both in summer and winter. In 1952 a shop was erected next to the Corbally Baths. The baths were closed in 1999 due to concerns about the water quality. (Courtesy of Sean Curtin)

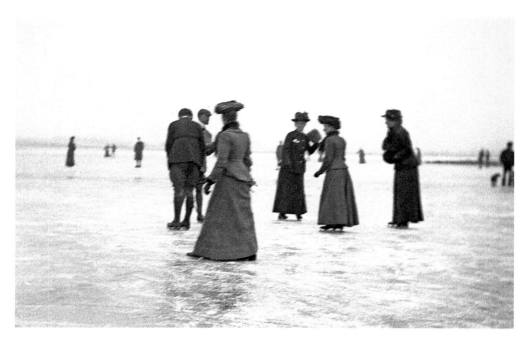

On the outskirts of the city, near Patrickswell, there was a lake known as Loughmore. During periods of prolonged frost the lake would freeze over enough to support skaters and locals. The skaters would arrive with picnics and chairs. In the late 1990s the lake was drained. In 1683, 1694, 1749, 1881, 1936 and 1963 the frost was so intense in Limerick that the Abbey and Shannon rivers were frozen. (Courtesy of the Ludlow family)

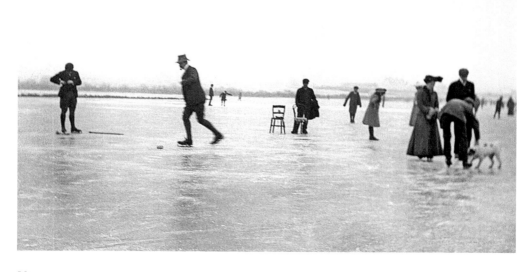

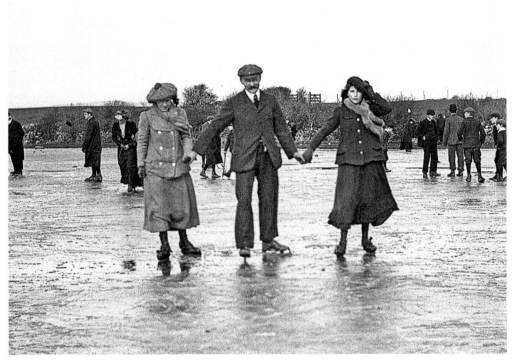

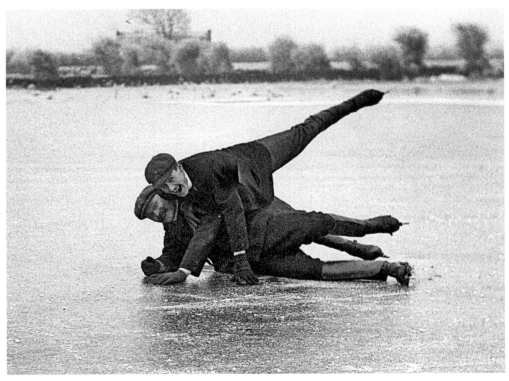

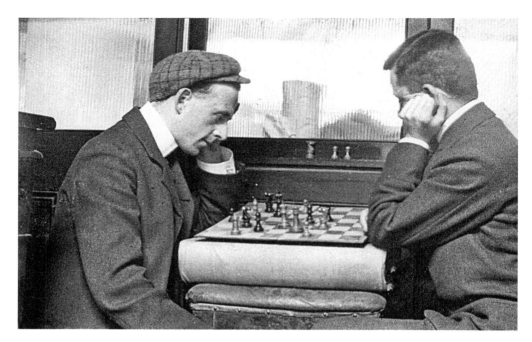

Chess in the Limerick Protestant Young Men's Association (LPYMA, formed 1853). The Limerick Chess Club was formed in the Limerick Athenaeum on Tuesday, 16 June 1885. The annual subscription for the Limerick Chess Club was 10 shillings. In 1925 the LPYMA and Limerick Chess Club held a Munster Championship Chess Tournament with participants from throughout the province. (Courtesy of the Ludlow family)

The LPYMA had a choral society, reading room and gymnasium; hosted Bible, literary and debating classes; and held frequent public lectures, soirees, musical festivals and conversaziones. Their tennis and cricket club was formed in 1887. In 1896 the LPYMA gymnastics team played against Dublin in the Irish Shield Competition. The Limerick team lost by 38½ points. (Courtesy of the Ludlow family)

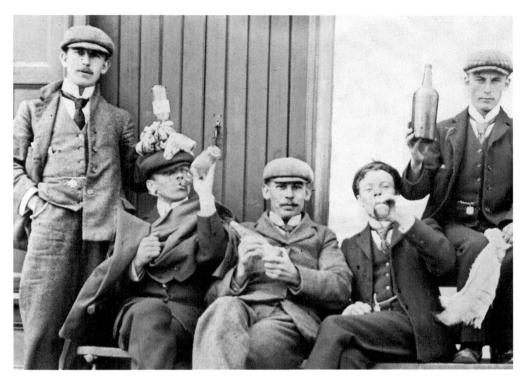

A group of LPYMA men enjoying a few drinks. In 2005 the LPYMA donated their archive from 1855 to the 1960s to the University of Limerick Special Collections. (Courtesy of the Ludlow family)

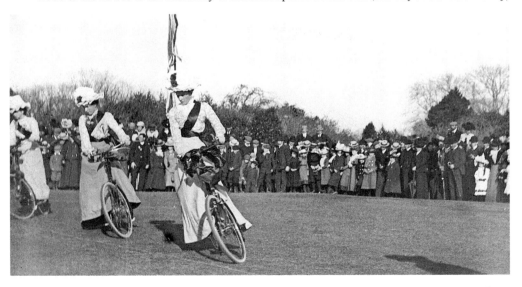

Female cyclists at the Lawn Tennis Club on Ennis Road, as part of a May Day event. There were a number of cycling clubs in the city, the Limerick Amateur, Athletic and Bicycle Club was in operation from the early 1880s. In 1887 Alexander W. Shaw was elected as president of the club. (Courtesy of the Ludlow family)

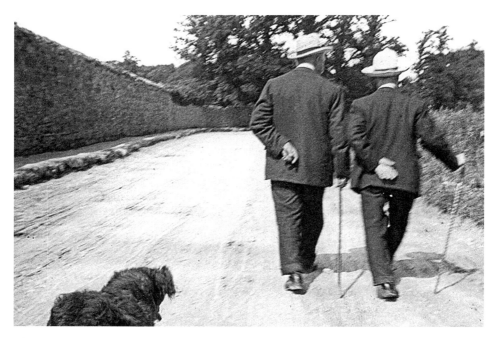

The road from Thomondgate to Parteen was a common area to walk. The village of Parteen was formerly known as Ardnacrusha but when the hydroelectric station opened in the area, the plant took the name for the station. In response, the locals decided to rename their village Parteen. Building of the Ardnacrusha Hydroelectric Power Station commenced in 1925 under the direction of the German firm of Siemens & Schuckard of Berlin and was completed in 1929. (Courtesy of the Ludlow family)

Island Field walk. This walk encircled the King's Island area of the city, beginning at the side of the O'Dwyer's Bridge, Athlunkard Street (left of picture) and ending at Thomond Bridge. The walk surrounds St Mary's Park housing estate, which was completed on 19 August 1935 and is one of the oldest corporation estates in Limerick. The first residents moved from slums in the Lady's Lane, Parnell Street and Palmerstown areas of the city. In 2014 large sections of this walk were washed away by major floods that hit that year. (Courtesy of Limerick Museum)

3

BUSINESS LIFE

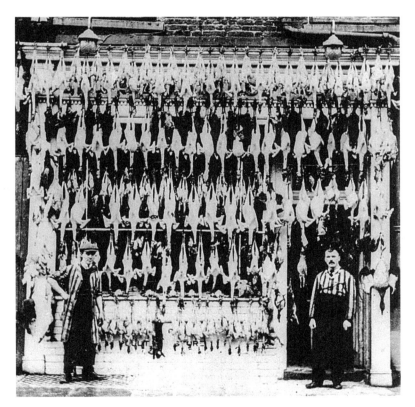

Denis Hayes ran a fish and poultry store at No. 57 Roches Street from 1910 until at least 1941. He passed away in 1955, aged 84. He was connected with the Abbey Fishermen's Guild, who supplied him with a large selection of fish, which he sold locally and exported to London. The fishermen's rights were removed during the Shannon Hydroelectric Scheme of the 1920s, which adversely impacted on his main suppliers. (Courtesy of Ger Hayes)

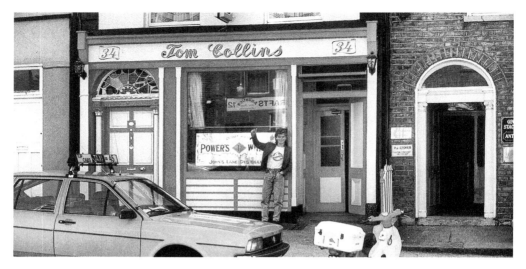

In 1988 this famed public house at No. 34 Cecil Street was known as Tom Collins. It had been known as Michael Collins with a very similarly painted sign from at least 1931 when Michael was applying to have his premises open between 2.30 p.m. and 3.30 p.m. during the Civil Carnival festival in September that year. Michael passed away in 1959. (Courtesy of David Zelz)

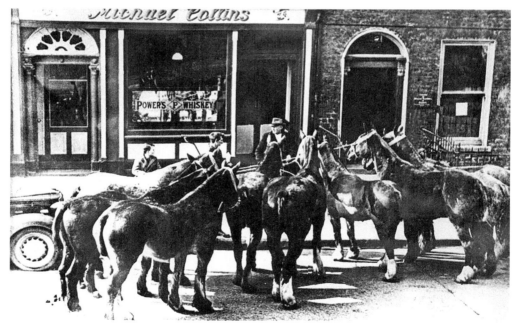

Hartigan's Horse Repository was located a few doors down from Michael Collins pub on Cecil Street. It had opened in 1846 after Michael Hartigan sold his site on the Roxboro Road to the Great Southern and Western Railway who were extending their line into Limerick. The original owner passed away in 1889, though his business lived on for many years, as this picture from the 1950s shows. The Hartigan name remains on an archway in Cecil Street to this day. (Courtesy of Limerick Museum)

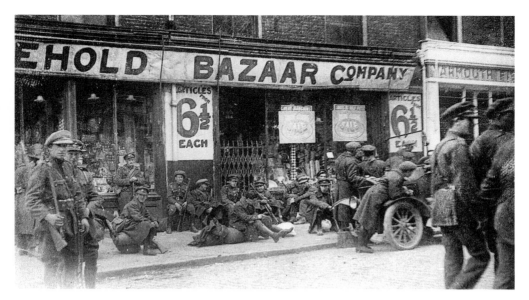

The Household Bazaar (better known as the 6½d Bazaar), at the corner of William Street and O'Connell Street. In December 1916 they advertised 'Better Value Impossible. All Goods from 6½ D Each.' They sold toys, glassware, fancy vases, photo frames as well as other 'Xmas Novelties'. Next door was the Yarmouth Fish Store. This picture was taken in July 1922 as the Irish Civil War tore through the streets of Limerick. (Courtesy of the Ludlow family)

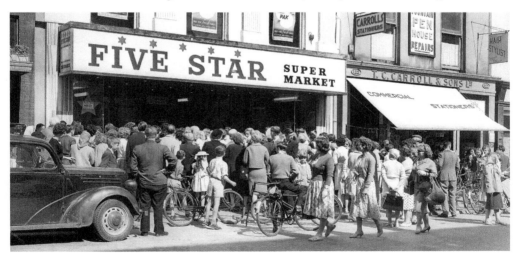

The Five Star Super Market opened in July 1961 on O'Connell Street, where Wacky Shoes is located today. The opening advert read, 'One of Ireland's most beautiful super marked "Five Star" opened to-day. Now you can shop under really ideal conditions in beautiful surrounds. Magnificent shelving and a suite of 5 most modern refrigerated unites keep foodstuffs-morning fresh vegetables and frozen foods fresher than ever. Pre-packed meat and bacon untouched by hand & a wonderful variety of Delicatessen, Cooked Meats, Cheeses and Exotic Foods. Background music. A pleasant, well trained staff in attendance – Speedy Self Service, in fact.' (Courtesy of Sean Curtin)

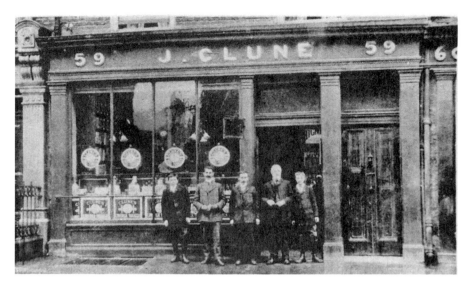

Clunes Tobacco suppliers was established by James Clune at No. 59 William Street while their factory on the corner of Denmark Street and Chapel Lane was established in 1872. His son, John Clune, managed the tobacco factory. The company produced Sarfield Plug and Kincora Plug. Other tobacco companies in Limerick were Clarke, McNamara and Spillane, who produced Garryowen Plug. (Author's Collection)

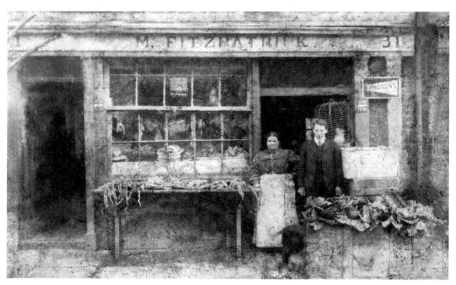

Mungret Street was once one of the main streets in Limerick, being located just off the main street of Irishtown. It was one of the principle entrance points to the city from the east and south, and as such was a hive of activity with business booming. However, as the city developed and locals began to relocate to the suburbs the area crumbled. This wonderful picture shows M. Fitzpatrick's of No. 31 Mungret Street. Besides operating this shop they also had a pub at the back as well as a funeral undertaking business and a lodging house. (Courtesy of Sean Curtin)

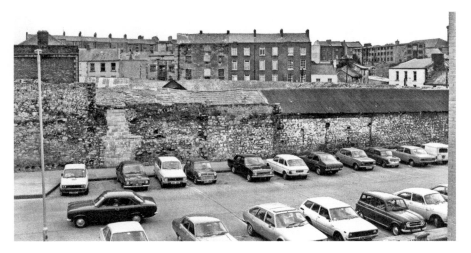

The Milk Market in the early 1980s bore little resemblance to the wonderful structure we have today. The Milk Market was founded in the 1850s by the Limerick Market Trustees. It had originally been intended as a market for the buying and selling of milk, with a corn, hay and butter market located in the area, but it soon developed into a household market for fresh fruits, vegetables, poultry and fish. In 1995 the Milk Market went through a major transformation as it was brought back to its former glory. In 2010 the market gained a roof for the first time. (Courtesy of Limerick Museum)

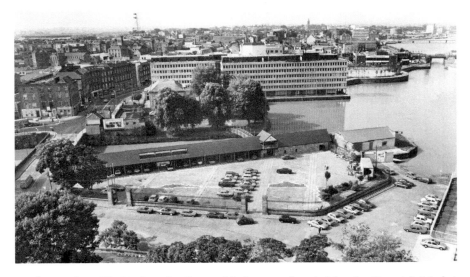

Similar to the Milk Market, the Potato Market was founded by the Limerick Market Trustees in the 1850s and remained in use until the 1940s. In 1989 a pedestrian bridge dedicated to the memory of Doctor Sylvester O'Halloran was built between the Potato Market and the rear of the Custom House, now the Hunt Museum. Sylvester O'Halloran was born in Caherdavin in 1728 and lived in Merchant's Quay for the majority of his life. He was a pioneer in cataract and amputation surgeries, changing how these were treated internationally. Not only was he a master surgeon, but he was also an avid historian and patriot, writing *A History of Ireland* in 1774. (Courtesy of Limerick Museum)

James Kirby operated a Limerick-Lace making store at No. 20 O'Connell Street until the early 1930s when he retired from the business. Limerick Lace is a uniform type of lace produced on a net and was very popular during the nineteenth century. Charles Walker introduced this style of lace making into Limerick in 1829. Even Queen Victoria was a fan of the craft and often presented it as gifts to other royal families in Europe. The room above Kirby's store was occupied by the famous photographer Franz S. Haselbeck. Haselbeck was noted for his scenes of the construction of the Shannon Scheme and of the Irish Volunteers. (Courtesy of Sean Curtin)

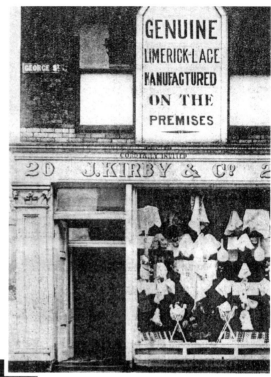

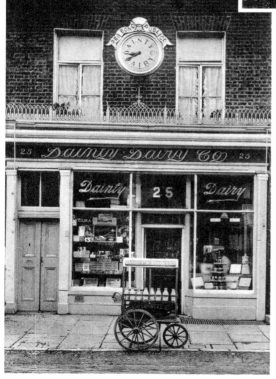

The Dainty Dairy opened at No. 25 O'Connell Street in 1912 by 26-year-old James Dooley. In 1911, James Dooley was a clerk to Petrolium Oil Company, living in Thomondgate with his parents. The building on O'Connell Street was incorporated into the Augustinian church. In 1929 they advertised as a 'palace of sweets; fruits and flowers'. The company later had premises on Bedford Row, Cecil Street and a bakery on Kileely Road. All three businesses were closed in 1982, with the loss of fifty jobs. (Courtesy of Limerick Museum)

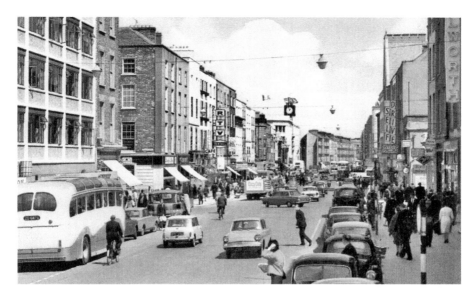

The George Hotel to the left of this image has gone through three major refurbishments and name changes. It was started as a coaching inn in 1820 and was a typical Georgian terraced building. It was owned by Patrick Lynch in the 1870s before being sold to Patrick Hartigan in 1889. The hotel remained in the Hartigan family until 1956 when it was sold to the former manager of Cruise's Hotel. The picture shows the building of the 1960s, which was opened on 2 June 1962. In 2006 the hotel once again went through a major refit and changed its name to the George Boutique Hotel. (Hinde Collection)

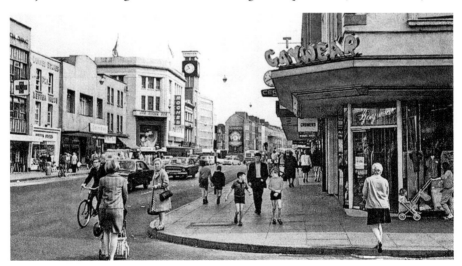

Roches Stores, on the left-hand side of the street, was founded by William Roche in Cork in 1901 and opened in 1937 in Limerick, taking over from John McBirney & Co. In 1947 the building was gutted by fire, it took four years to rebuild and reopen the store. The new store was very sympathetic to the original architecture. In 1986 the store was extended and a new supermarket to the rear of the store was opened. All of the Roches Stores in the country were bought by Debenhams in 2006. (Hinde Collection)

The three McSweeney brothers, from left to right John, Denis and Patrick, together with an unidentified customer, posed outside McSweeney brush factory in the Milk Market Street. In 1911 all three men were unmarried brush-makers and living with their widowed mother, Catherine in Benson's Lane. Their father Denis, who passed away in 1904, had been a brush maker before them. Their mother passed away in 1912. In 1870 there were nine brush-making companies in Limerick with this reducing to just the McSweeney brothers by 1900. Stephen Hastings operated as a brush-making factory from at least 1838 until 1880. He was the Mayor of Limerick in 1878. (Courtesy of Limerick Museum)

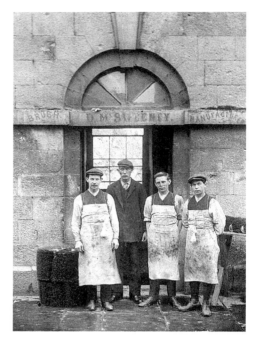

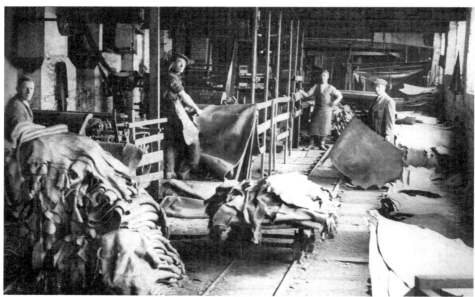

The Limerick City Tannery (Tan Yard Lane) was founded by Eugene O'Callaghan in 1830 and was once a thriving industry in Limerick. O'Callaghan was the Mayor of Limerick in 1864. The 'Murdered Mayor' Michael O'Callaghan was the owner of the tannery until his death in 1921. This picture, taken around 1945, shows a group of workers. The premises was gutted by fire in 1950. The lane changed even further in 2015 with the demolition of the old Halpins Tea premises (known latterly as Miss Tuckers Brewery) along with Tom Clifford's house. The official name of the lane is Old Windmill Street. (Courtesy of Sean Curtin)

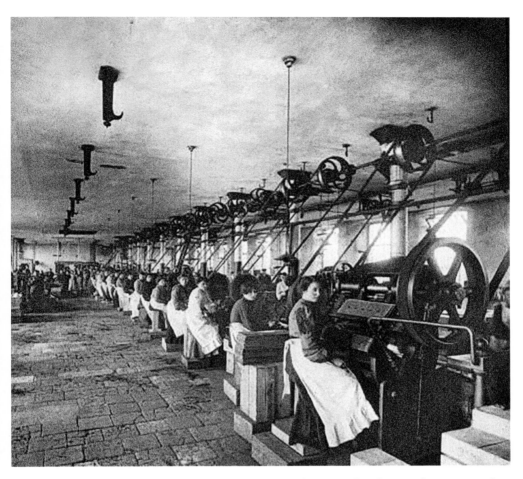

The Cleeve's Condensed Milk Factory was established in 1883 by Thomas Cleeve, a Canadian of English extraction. Cleeve first came to Ireland as a teenager to work for J.P. Evans & Co., a Limerick-based supplier of agricultural machinery owned by his uncle. Over the next twenty years Cleeve rose to become managing director of this company. By the end of the nineteenth century the Condensed Milk Company had 2,000 employees on its payroll and counted 3,000 farmers as suppliers of its raw material. By November 1923, the directors decided they could not continue and announced that the company was going into liquidation. In 1927, the Free State government established a new semi-state body, the Dairy Disposal Company, to regularise and rationalise the industry. The new body took over the Condensed Milk Company. The image is of Cleeve's can-making section. (Mason Collection, NLI)

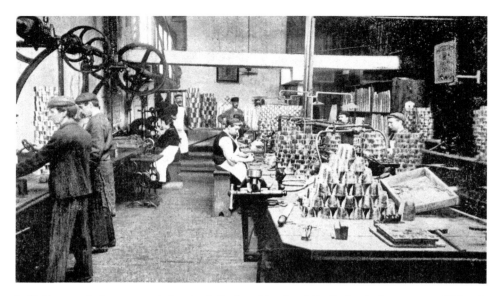

J. Matterson & Sons operated out of Roches Street, while their rival company O'Mara's operated across the road on the same street from 1839. Mattersons was established in 1816 by John Russell and J. Matterson, who were brothers-in-law. Both men married a Mossop sister, Mary and Eleanor. After the death of Joseph Matterson Snr in 1854, Joseph Matterson Jnr took over the Limerick aspect of the company. While Joseph Matterson Snr's other son, William Matterson, oversaw the London branch of the business. William Matterson died aged 71 in London in January 1903. Not only was Joseph Matterson Jnr a business owner in the city but he was also a key player in the community and vice patron of the Protestant Young Men's Association. The image is of the canning room and sausage room. (Mason Collection, NLI)

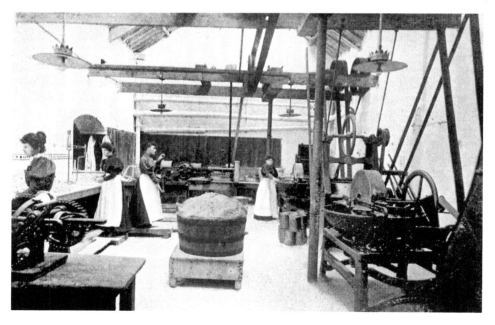

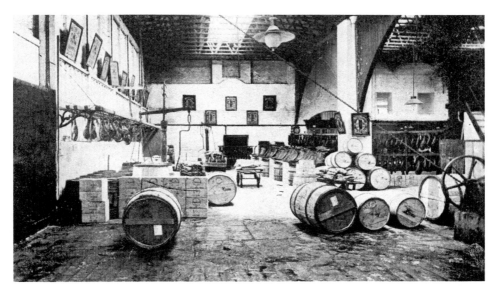

Inside Matterson's. Limerick is well known and famed for its bacon production, 'everything but the squeak was used'. Many of the households in areas such as the Abbey kept pigs along with the more traditional chickens, usually fed on domestic scraps as well as on root crops, although the vast majority of the pigs were imported from the local environs. Thousands of pigs were slaughtered and processed weekly in the Limerick bacon factories and at the height of their production their's was the most consumed pork products in the British Isles. In the nineteenth century Limerick hams became renowned throughout the British Empire with Queen Victoria insisting on Limerick hams at her Christmas dinner. Limerick pork sold through the O'Mara's was even exported as far away as Russia and Romania in 1891 and 1902 respectively. (Mason Collection, NLI)

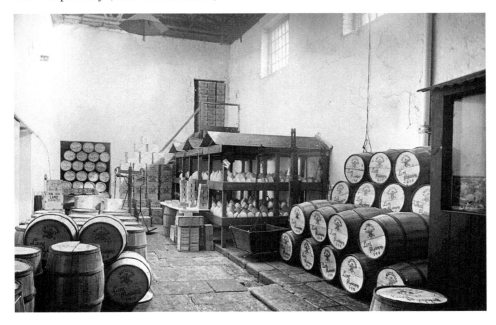

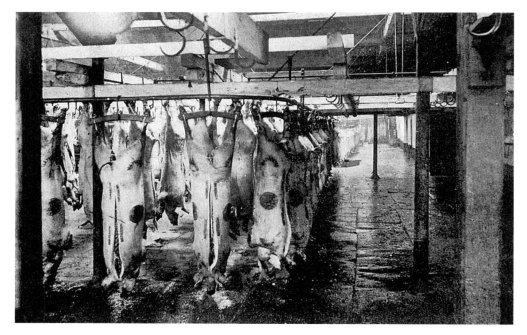

The four great bacon factories in Limerick were Matterson's, Shaw's, O'Mara's and Denny's, each competing for local, national and international trade out of Limerick city during the nineteenth and early twentieth centuries. Other bacon merchants in Limerick city during this period were Hogan, Longbottom, Looney, Lynch & Spain, Neazor, O'Brien, O'Connor, O'Halloran, Prendergast, Rea, Sullivan, and Thompson. (Mason Collection, NLI)

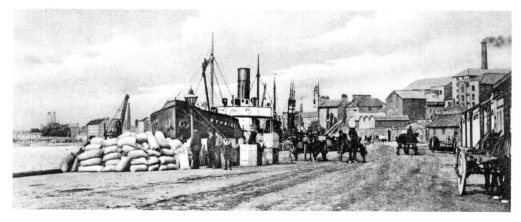

Prior to the construction of the floating dock at Steamboat Quay, goods were brought into the city at the quays, namely Arthur's Quay, Merchant's Quay, Howley's Quay, Bishop's Quay, Fisher's Quay and Harvey's Quay. There was also a dock on the north bank of the Shannon where Shannon Bridge is today. On 18 September 1845 the first public enquiry was held at the Tidal Harbour Commission where the Limerick Bridge Commissioners and the Chamber of Commerce argued convincingly for a floating dock to be built in Limerick Harbour. The first stone for the dock was laid on 6 July 1849 by the Mayor of Limerick John Boyse. (Courtesy of the Ludlow family)

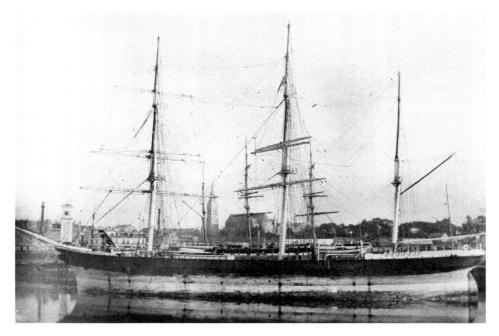

The floating dock was finished in 1853 and opened by Edward Eliot, 3rd Earl of Germans and Lord Lieutenant of Ireland, on 26 September 1853. The final cost for construction was £54,000, of which £39,000 was labourer costs. During the initial construction it was discovered that the entrance to the dock was at the wrong end, causing difficulty for ships trying to enter and leave the docks. (Courtesy of the Ludlow family)

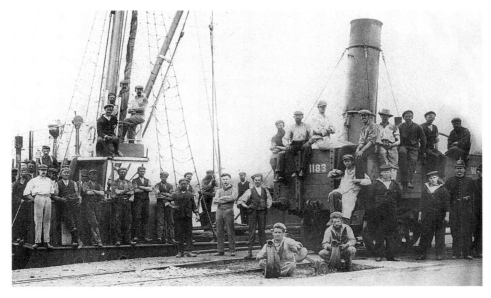

Dockers with coal dust on their faces at the Limerick Docks, on a boat that uses both steam and sail power. In front of them is a railway cart on tracks. Also in the picture are two naval sailors and two members of the Royal Irish Constabulary. (Courtesy of the Ludlow family)

The Dock Clock was
'Erected for the Benefit of
this Port by the Limerick
Harbour Commissioners
1880 William J. Hall
B.E. Harbour Engineer
William Carroll Secretary
M. Fitzmaurice H. Master.'
The stone plinth reads:
'Foundation Stone, laid
by Miss O'Gorman,
Daughter of The Right
Worshipful Mayor of
Limerick 1879–80', while
the plaque to east reads:
'Lund & Blockley 42 Pall
Mall London Makers of
the Clock.' (Courtesy of
the Ludlow family)

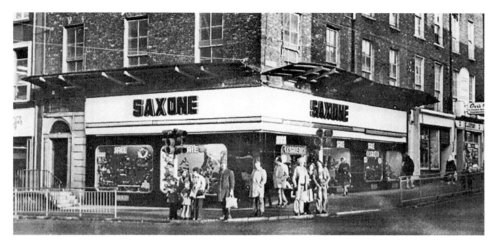

Saxone Shoes store opened in Limerick in 1927. This picture was taken just prior to the building's collapse at 7.45 p.m. on 20 November 1986, injuring one man. A new Saxone Shoes was built on the same spot and opened in 1989. The site is now occupied by Keanes Jewellers. Keanes was founded in Cork in 1948 and opened in Limerick in 2002. (Author's Collection)

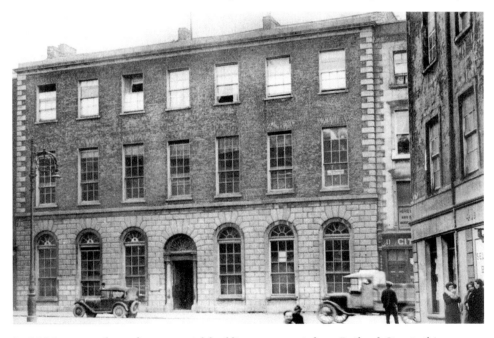

In 1805 a stone-fronted commercial building was erected on Rutland Street; this was an early building in the newly expanding Georgian city. The first occupant was the Limerick Chamber of Commerce. When the Chamber moved in 1833 the building went through a number of tenants, mostly newspapers, until 1846, when the newly reformed Limerick Corporation took over the building until 1990 when they moved to Merchant's Quay. The building was used by the *Limerick Post* newspaper and as a private third-level college until 2006 when it was bought for the proposed Opera Centre. (Courtesy of Limerick Museum)

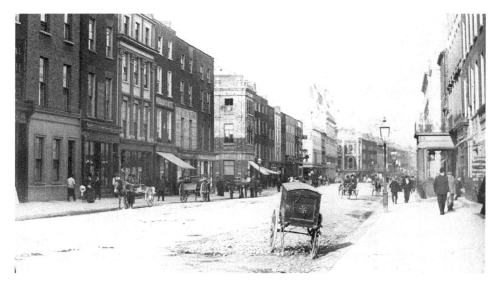

Limerick's main streets were dirt roads until relatively recently and most houses had boot scrapers at their front doors. The city employed men not only to sweep the roads, but also to shovel manure left by livestock going through the city to the many factories. In the summer, when the roads became dry, they were also responsible for wetting the roads to prevent them from becoming too dusty. (Courtesy of the Ludlow family)

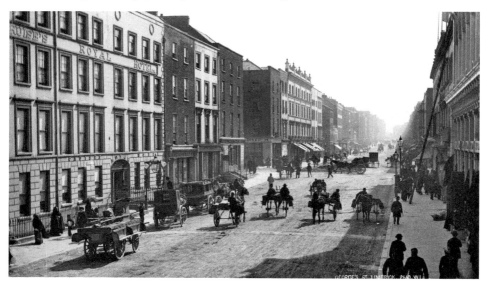

Cruise's Hotel, first owned by George Russell Francis, opened in 1791. At the time the hotel was the Limerick stop for the Dublin Mail Coach; it was much later that Edward Cruise took over the hotel, renaming it after himself. Those who stayed in the hotel included politicians Daniel O'Connell, Michael Collins and Eamon de Valera. De Valera always asked for room number 249. Other visitors were Charles Dickens, Gene Kelly, Gregory Peck, Maureen O'Hara and Mohammed Ali. The hotel closed in 1990 and was soon demolished to make way for the pedestrianised Cruise's Street. (Lawrence Collection, NLI)

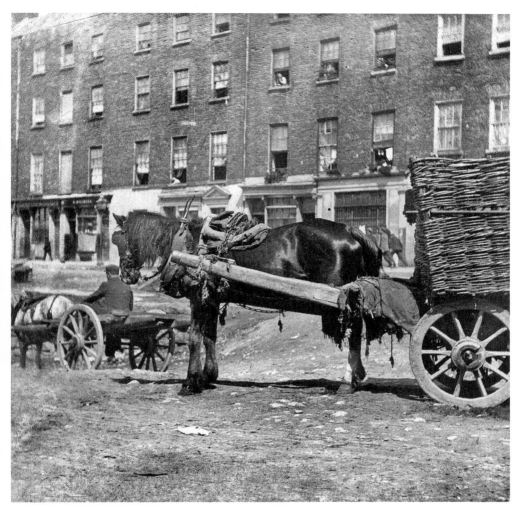

Arthur's Quay was named after the prestigious Arthur family, members of whom had held the position of Mayor of Limerick forty-four times. As the old walls of the city were torn down in the late eighteenth century and the city expanded into what we now know as Newtown Pery, the Arthurs set to work, building both buildings and streets. The streets were named after members of the family, Ellen, Francis and Patrick. Patrick Arthur's house was No. 1 Arthur's Quay. In 150 years the block fell from being the most prosperous into a tenement. At the turn of the twentieth century, ships were still being moored at Arthur's Quay, here they would load and unload goods from the quays. The large wicker baskets seen here on the horse carts were often used to carry turf and coal. (Courtesy of the Ludlow family)

A distillery operated in Thomondgate for almost a hundred years up to 1919. It was situated on 6 acres of land on Brown's Quay. In 1868 the distillery was bought by Archibald Walker. When John Riddell, from Glasgow, joined as the manager, it was known as Walker's Distillery. Riddell was an amateur photographer and great-grandfather of the Ludlow family. He produced hundreds of unique views of the city and surrounding area. In 1886 there were seventy people working in the distillery and 300,000 gallons of whiskey were being produced annually. (Courtesy of the Ludlow family)

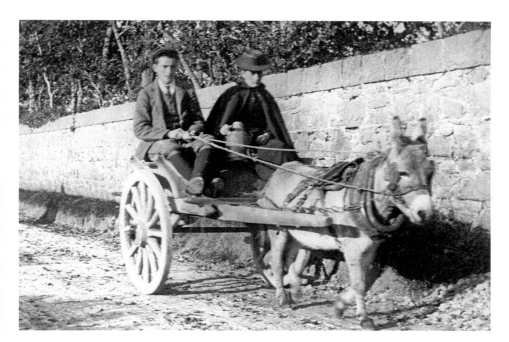

The land surrounding Limerick is very fertile and farmers from the hinterland would bring their produce in to the markets and stores. This couple are travelling along the Parteen Road toward the city. (Courtesy of the Ludlow family)

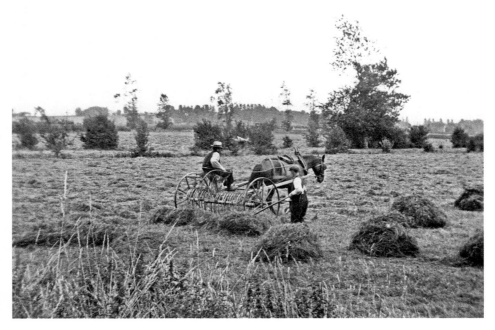

The farmland around the city was quite rich and produced ample supplies for the city, being sold at many of the local markets. These farmers are using a horse-drawn raking machine to draw hay together. This farm was on the Parteen side of the city. (Courtesy of the Ludlow family)

Longpavement railway line closed in 1963 after running for almost a hundred years. It had been a part of the Waterford and Limerick Railway and was a stop on the Limerick to Ennis line. This line was a vital link during the Ardnacrusha Hydroelectric Scheme when a line was connected to the Limerick Docks. This enabled all the materials needed for construction to be transported quickly and easily. (Courtesy of the Ludlow family)

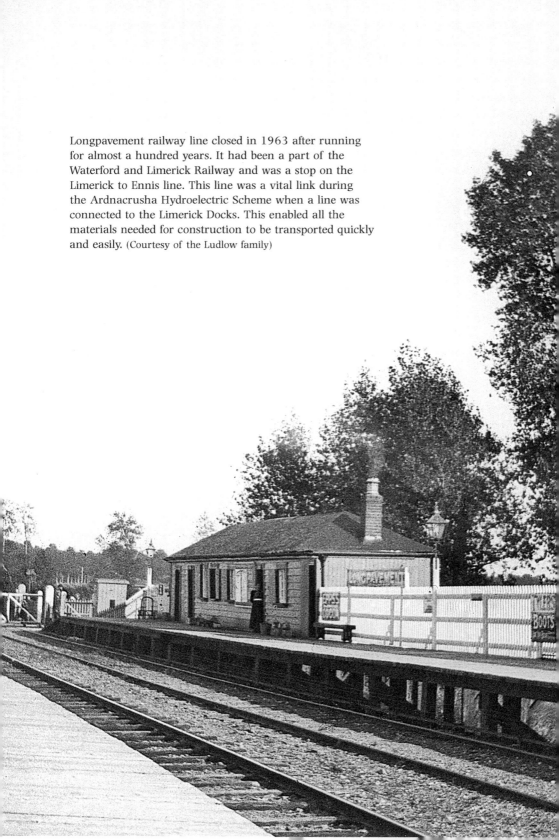

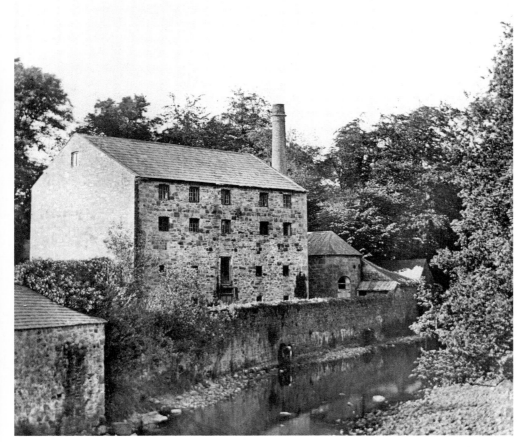

Blackwater Mill, Parteen. In 1848 the mill was bought by James Bannatyne but later that same year it was consumed by a fire. The Bannatyne family were well-known Limerick merchants well into the twentieth century, having owned what became known as the Ranks Mills. Blackwater Mill had been built by Samuel Caswell, who died only two years after Bannatyne bought the mill. In 1850 flour was sold in sacks, these were classified in quality depending on when they came off the mill wheel; the first flour to come off the wheel cost 31 shillings, while the fourth cost 23 shillings and 4 pence. (Courtesy of the Ludlow family)

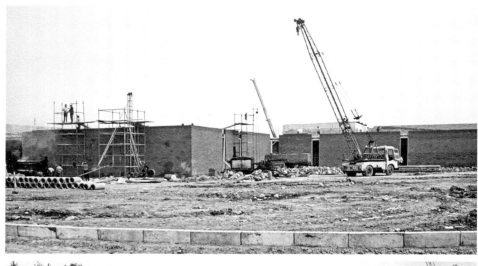

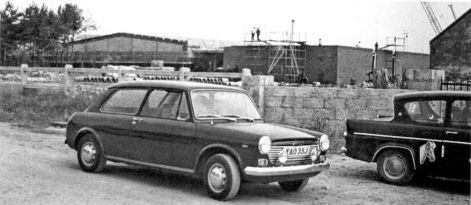

These pictures show the building of the Crescent Shopping Centre in 1972. At the time it was the biggest shopping centre in the country. The initial build was on a 17-acre site and had parking for 1,000 cars. It was originally named the 'South West Regional Shopping Centre'. The doors opened in November 1973 and Shaws' Department Store is the last of the original stores in the centre. The first anchor supermarket was Five Star, this later became Quinsworth and today it is Tesco. The original site included a Shell service station. (Courtesy of Reg Morrow)

4

TODD'S FIRE

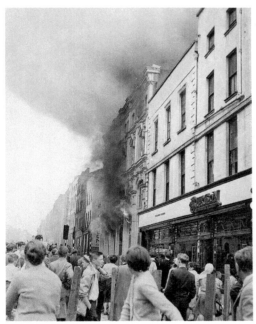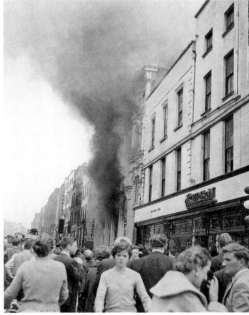

The William Todd & Co. Ltd department store occupied about four-fifths of a large city block fronting on to O'Connell Street, between William Street and Thomas Street in Limerick city, where Brown Thomas stands today. On Tuesday, 25 August 1959, at 11 a.m., a fire was noticed and reported in the building. The Todd's and the neighbouring buildings were quickly evacuated and crowds began to gather at the scene. (Courtesy of Eugene Barry)

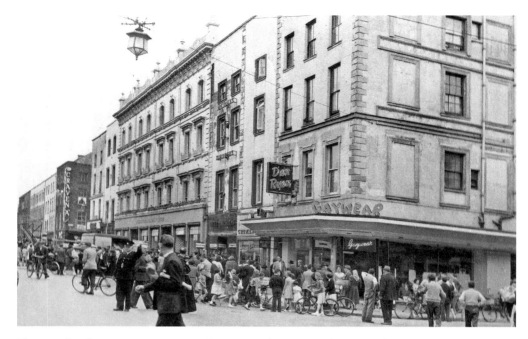

The sign for Craven A cigarettes can be seen at the corner of O'Connell Street and William Street. Craven A cigarettes were produced locally at the Spillane's tobacco factory which was based on Sarsfield Street. The factory closed in 1958 after operating in Limerick for 130 years. (Courtesy of Eugene Barry)

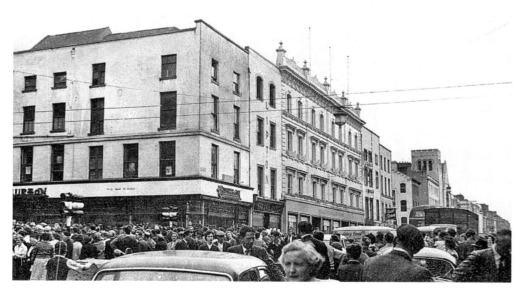

Soon the streets were a mass of people evacuated from the buildings and those gathering to see what the excitement was about. (Courtesy of Eugene Barry)

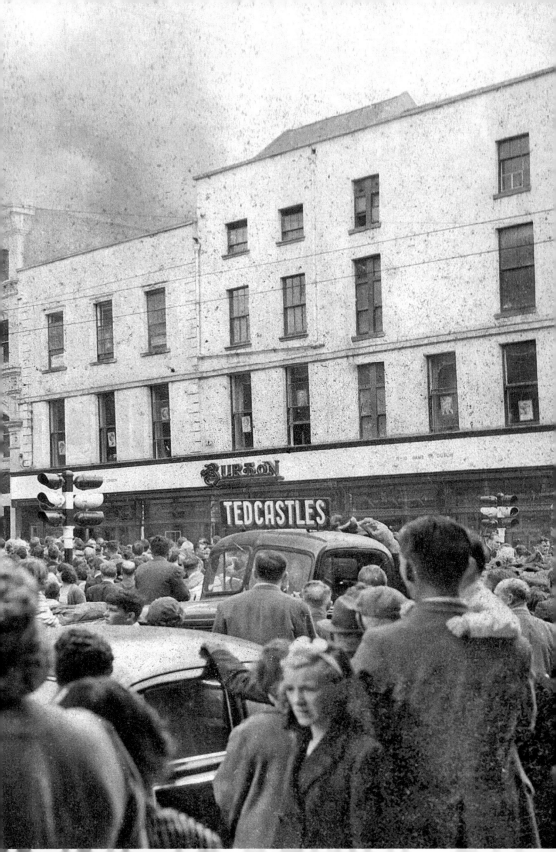

The head waiter of Cruise's Hotel cames out to investigate the commotion still in his tuxedo. (Courtesy of Eugene Barry)

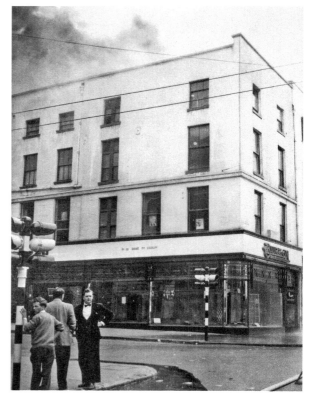

Todd's van on Thomas Street. The van's number plate was TI6774. It was a Ford, registered by Todd's on the 10 May 1955. Goods removed from the building were taken to the Bedford Rink and the Crescent Clothing Company for storage. (Courtesy of Eugene Barry)

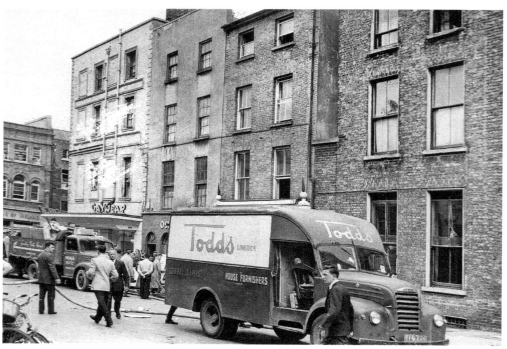

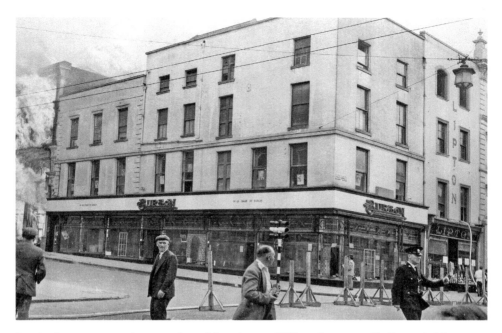

Barricades were erected to stop the public going up William Street outside Burton's Menswear. Burton's was founded by tailor Sir Montague Maurice Burton (1885–1952) in Chesterfield, Derbyshire, England in 1903. (Courtesy of Eugene Barry)

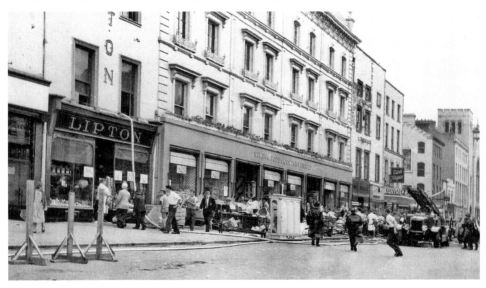

As the fire took hold the hope of saving stock decreased and an hour and a half after it started the entire block was a blazing inferno. The staff of Todd's and Lipton's began moving goods out of the buildings as the fire brigade began pumping water into both premises. There were over thirty hoses used during this process. Eleven fire brigades were in attendance: Limerick, Cork, Shannon Airport, Rathkeale, Kilmallock, Charleville, Fermoy, Sarsfield Barracks, Ranks, Tipperary and Ennis. (Courtesy of Eugene Barry)

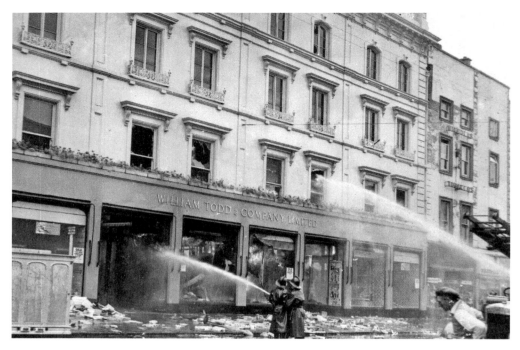

The cause of the blaze was a fuse box in the basement of the drapery store, which had burst from the wall. Sean Hanrahan was one of the first to notice smoke and raise the alarm. He worked then in the men's 'drapery' department. He subsequently worked in the new Todd's for many years, eventually becoming general manager. (Courtesy of Eugene Barry)

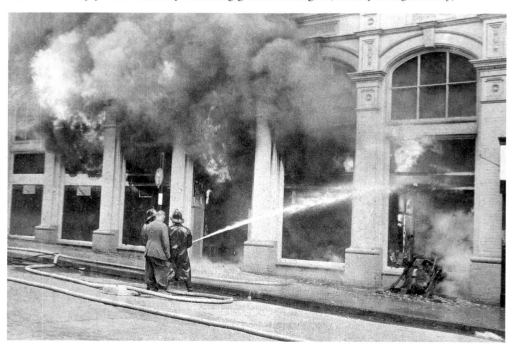

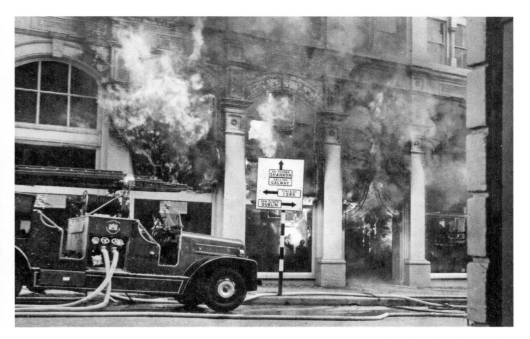

The heat of the blaze was so intense that the fire truck had to be abandoned and when the firemen returned the side had been destroyed. Chief Thady McInerney of Lelia Street was the leading fireman during the disaster, having being promoted to the position in 1947 aged 32, after serving two years with the brigade. He retired from the brigade in 1977. It was said that McInerney had witnessed every big fire in Limerick and had been at the scene of two major crashes in Shannon Airport. (Courtesy of Eugene Barry)

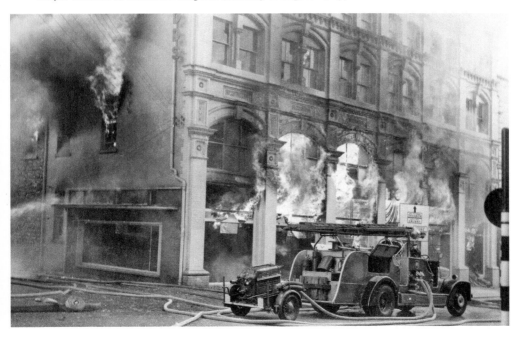

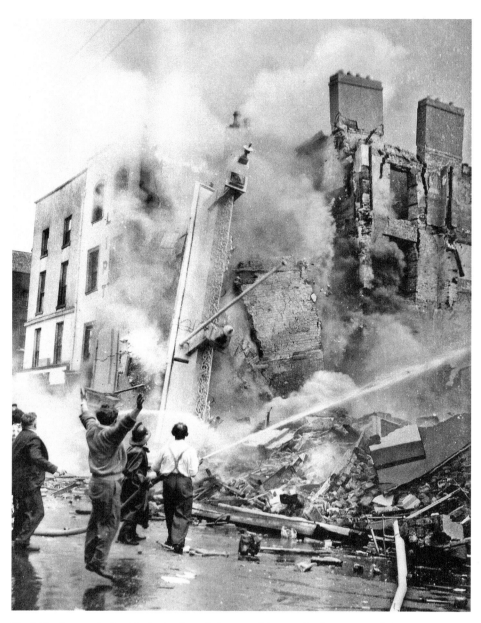

Noel Hanley worked with the Irish Red Cross and he recalls the events of that day: 'It was during that time frame that Todd's went up in flames, and we parked the Red Cross Ambulance at the corner of Bedford Row and O'Connell Street. Our first priority was to evacuate the patrons from Sullivan's Bar in Thomas Street as smoke started to enter from the restrooms area. During this trek we also liberated some Hennessy's Cognac, which was taken to the ambulance, Mullany's Restaurant donated a large churn of fresh tea, and this is when we went slightly wrong. We added the contents of our bottles to the churn, and it tasted pretty good! Now the bad news, I went to relieve the fireman with the hose trying to dowse the flames above the jewellery shop next to Todd's.' (Courtesy of Eugene Barry)

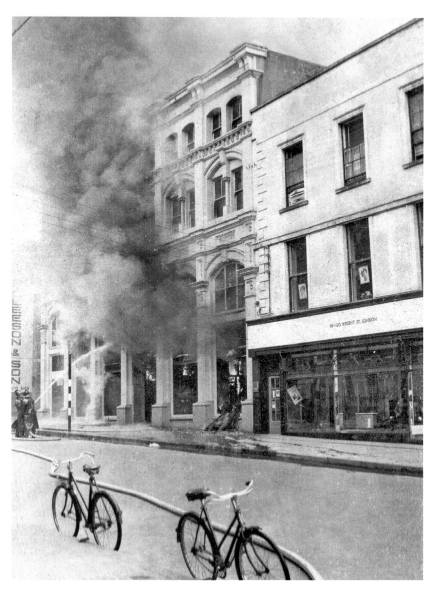

'As the firemen got replenished, we were slightly inebriated and suddenly the entire front of Todd's facade crashed to the ground. We could hear a gasp from the onlookers that gathered, but when the smoke and dust settled we were both still erect, aiming the hose at where we thought the window was previously. Lacking pressure in the hose (the tide was out), we were unable to break the windows of the hairdresser's above Burton's Tailoring on the corner of William Street. This is when we reverted to throwing stones to try and break the glass. Unfortunately, we could not hit the side of the building as the bricks we threw were landing and causing havoc in William Street. Somewhere around this time, we lost one fire tender, and resumed trying to prevent the telephone wires leading into William Street Garda station from melting completely.' (Courtesy of Eugene Barry)

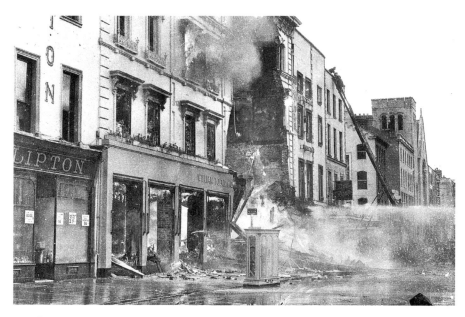

'Faced with a lack of hoses, no pressure, the fire raged on. I resorted to throwing a steel bucket filled with water through the plate glass window of Burton's store front on William Street. This enabled the fire to take control and burn the entire block from William Street to Thomas Street to ground level and below. The only remaining feature was a large safe on what was the second floor. [In the] days following a helicopter was used to assist in demolishing what we failed to achieve. And a good time was had by all.'
(Courtesy of Eugene Barry)

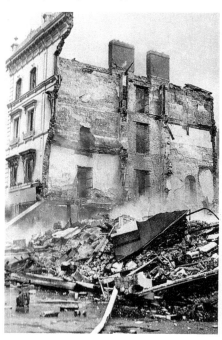

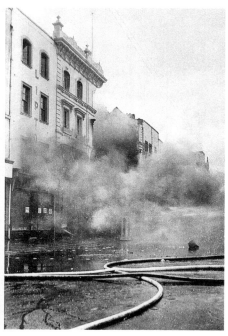

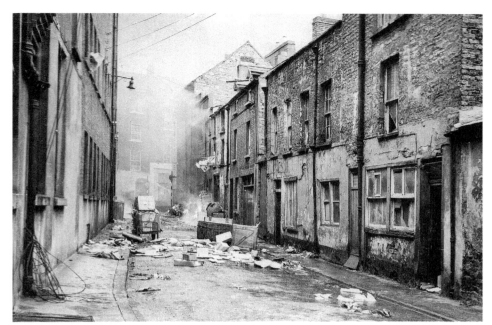

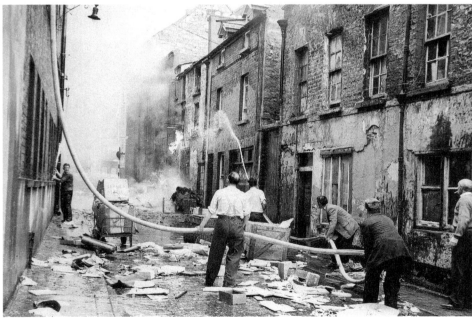

A fund was opened by Mayor John Carew in the weeks following the disaster to not only help the employees who were left jobless after the fire but the ten people who lived in Little William Street and who lost their homes to the flames. Malachy Skelly owned a betting office, Michael Gleeson owned a pub and Jack Flanagan had a house in this lane. Houses in Little William Street stood derelict for five years before finally getting demolished in 1964. Two men, Jim McInerney and Christopher McCarthy, were injured as one of the houses collapsed during this processes. (Courtesy of Eugene Barry)

In the days that followed the fire the Limerick post office employees worked at repairing the phone cables that ran to and from the building. These had been completely destroyed in the fire. Alternative traffic routes had to be put in place as William Street, O'Connell Street, Thomas Street and Little William Street remained closed following the fire. The bus that would usually stop outside Todd's was moved to the Augustinian church.
(Courtesy of Eugene Barry)

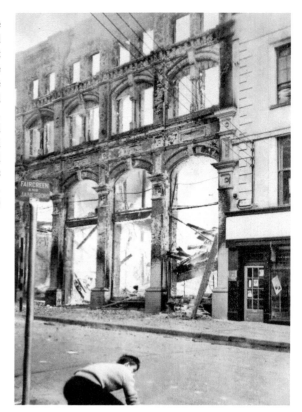

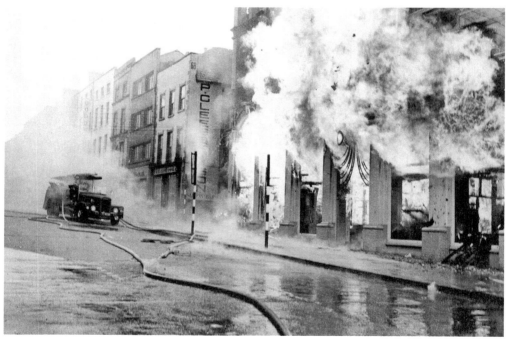

Former employees turned up daily to seek work during the demolition process. No one knew what remained in the rubble and whether any of the safes remained intact. It turned out that the Remington safe, which contained a large section of Todd's paperwork, including debtors' ledgers, remained intact with all contents undamaged. A week after the fire a large section of the remaining building collapsed, pulling the entire wall of Nicholas' tobacconist shop with it.
(Courtesy of Eugene Barry)

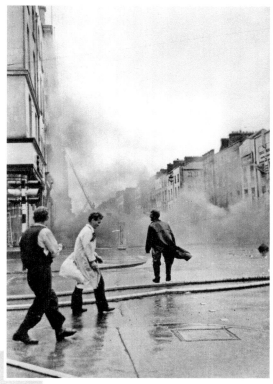

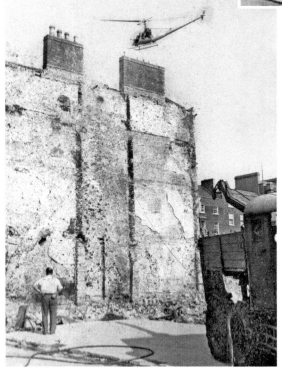

In the days following the fire a helicopter was used to photograph the scene.
(Courtesy of Eugene Barry)

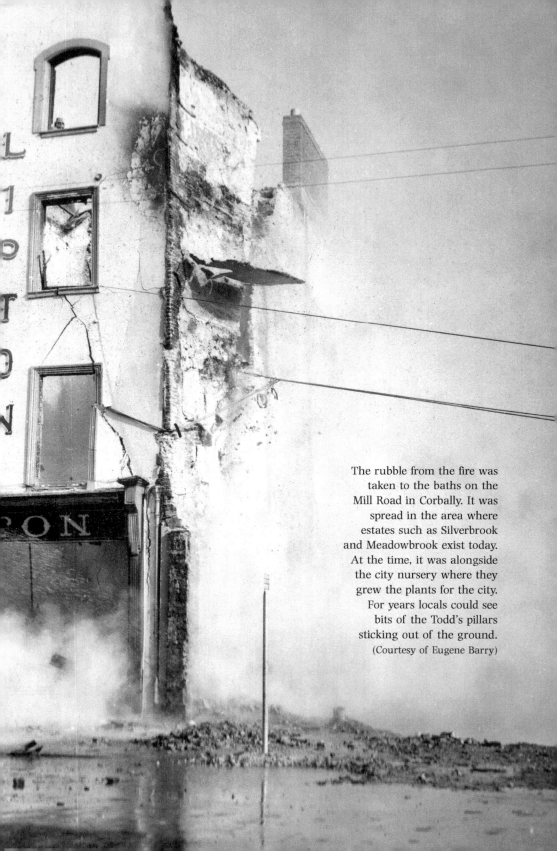

The rubble from the fire was taken to the baths on the Mill Road in Corbally. It was spread in the area where estates such as Silverbrook and Meadowbrook exist today. At the time, it was alongside the city nursery where they grew the plants for the city. For years locals could see bits of the Todd's pillars sticking out of the ground.
(Courtesy of Eugene Barry)

5

RIVER LIFE

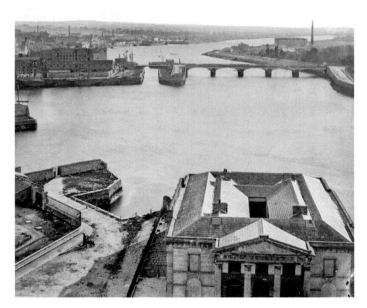

This picture was taken around 1900 from the tower of St Mary's Cathedral. The Shannon Boat Club is missing from Sarsfield Bridge. At the time the swivel section of Sarsfield Bridge was still in operation and we can see tall ships moored along the quays wall at Francis Street. This image predates the Curragower Boat Club, which is now situated to the left of the courthouse in front of the Potato Market. Cleeve's factory with its towering chimney is one of the few buildings on the North Strand. (Underwood & Underwood Collection)

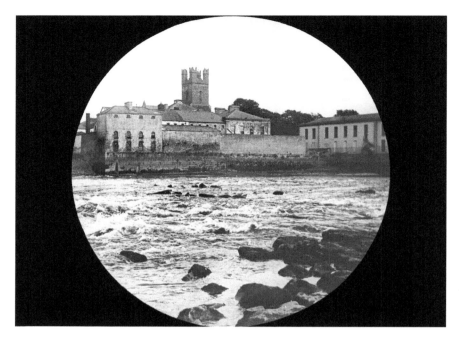

Looking across the Curragower falls in 1900 to the remnants of the female gaol in front of St Mary's Cathedral. This building was constructed in 1813 on land then known as Dean's Close and was demolished in 1988 to make way for the construction of City Hall, completed in 1990. It was used as Geary's Biscuit Factory for over seventy years. The factory produced a wide range of biscuits and confectionary and also acted as an agent for other manufacturers. The main method of sales distribution was via direct sales to customers delivered by the firm's van fleet to Cork, Tipperary, Limerick and Galway along set weekly routes. (Courtesy of the Ludlow family)

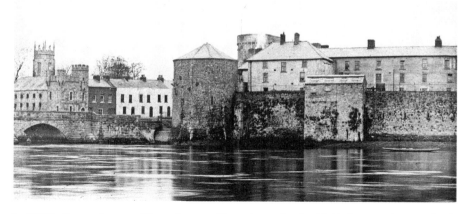

In 1900, the castle was still used as a military barracks. In 1791 the British Army built military barracks suitable for up to 400 soldiers at the castle and remained there until 1922. In 1935 the Limerick Corporation removed some of the castle walls in order to erect twenty-two houses in the courtyard. These houses were subsequently demolished in 1989 when the castle was restored and opened to the public. (Courtesy of the Ludlow family)

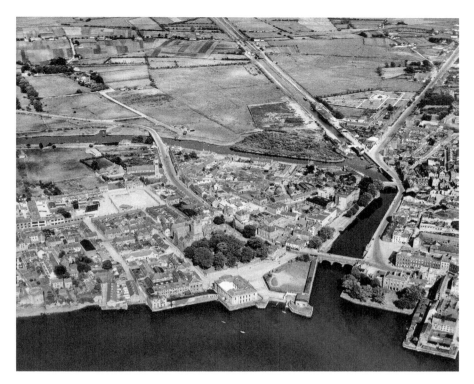

An aerial view of the Englishtown from the 1940s shows the three waterways of Limerick city, the large expanse of the Shannon River in the foreground, the winding Abbey River circling the urban area and the straight canal stretching from the Abbey River through the countryside diagonally in the background. This image also shows O'Brien's Park on Clare Street (between the canal and the road) not long after it was developed. A drinking fountain bearing the arms of Peter Tait stands in this park. This fountain was erected in 1866 in the grounds of the Limerick Clothing Factory. (Author's Collection)

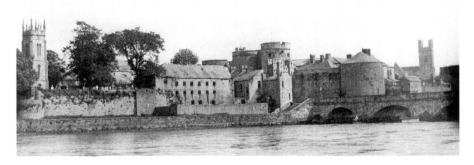

The large warehouse on Verdant Place on the banks of the Shannon was demolished by 1902. The tower-like structure at the corner of Thomond Bridge was built as a tollhouse in the 1840s. It was designed by the Pain Brothers who also designed Thomond Bridge, which was completed in 1840. (Courtesy of the Ludlow family)

Although it appears that there is snow on the roof of the castle, this picture was in fact taken by the light of the moon from Walkers Distillery looking towards the city. (Courtesy of the Ludlow family)

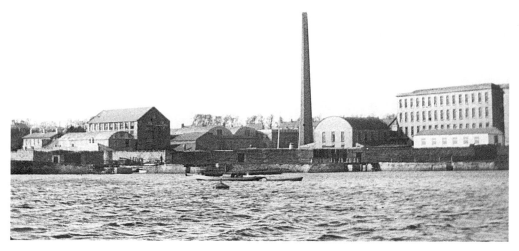

In 1852 a destructive storm hit the city and the chimney of Russell Flax mill (later Cleeve's Condensed Milk Factory) fell. 'The large chimney shaft, in connection with the extensive flax factory, erected by the firm of Messrs' Russell and Sons, at North Strand, and which had been built to a height of 160 feet, has also fallen a prey. It fell, for the greater part, with a tremendous crash. The loss of this alone is about £500. The damage to the shipping is set down at £4,000.' (Courtesy of the Ludlow family)

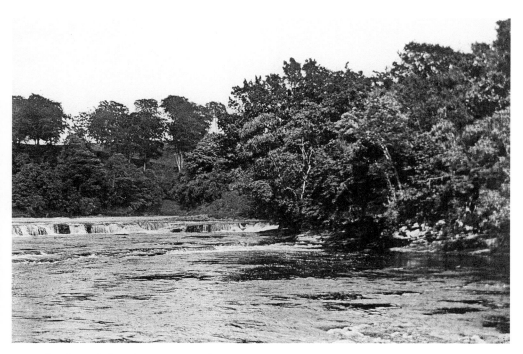

The flow of the Shannon River has been changed many times over the centuries to assist the people of Limerick. At the Mill Road, Corbally, a channel was cut to guide water towards the millwheel, which was powered by water. Before steam power arrived in Limerick mills sat along the Shannon, making use of this powerful resource. (Courtesy of the Ludlow family)

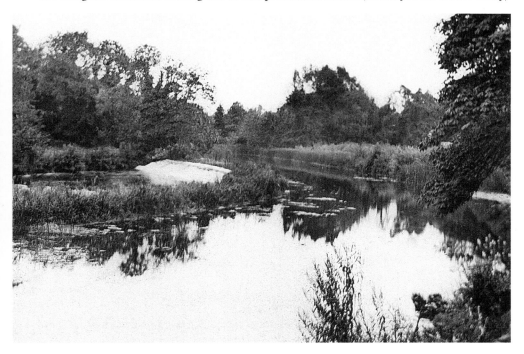

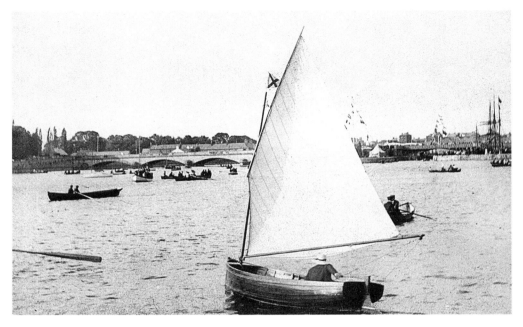

The Shannon River in full use in the early 1900s, over twenty pleasure boats can be seen on the river while a tall ship is moored at Sarsfield Bridge. Regattas were held on the Shannon for over a hundred years. In 1866, Shannon Boat Club was founded with members of the Cannock and Tait department store being the first crew. The original clubhouse was located in Bank Place, followed by Thomas Street, until the purpose-built clubhouse was erected off Sarsfield Bridge. The building was designed in 1902 by architect William Clifford Smith (1881–1954) and opened in 1906. (Courtesy of the Ludlow family)

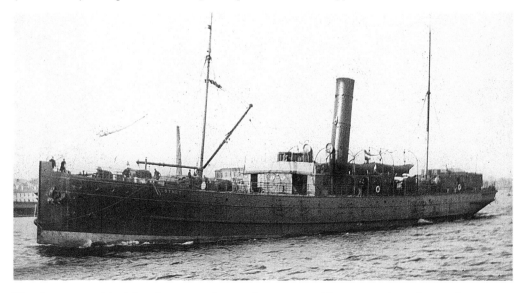

The river was not just for pleasure and many large steam ships ventured up-river as far as Limerick. (Courtesy of the Ludlow family)

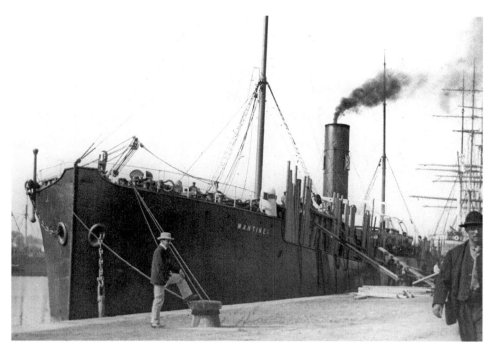

The SS *Mantinea* was built in Glasgow and launched on 30 April 1896 in Liverpool. It travelled between Canada, Ireland and England. On 7 August 1917 she was torpedoed by UC-63 while anchored off Newcastle, England, destined for Genoa, Italy, with coal. (Courtesy of the Ludlow family)

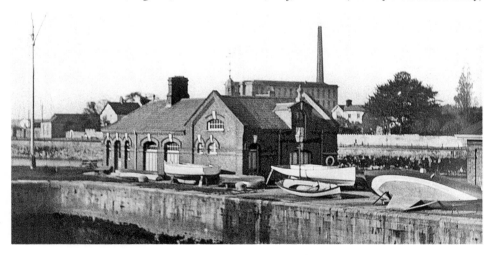

On 3 February 1870 a meeting was held at the reading room of the Athenaeum on Cecil Street with noted Limerick names, including Eugene O'Callaghan and Ambrose Hall, present, whereupon the Limerick Boat Club was established. A subscription was raised for a purpose-built clubhouse off Sarsfield Bridge; this was almost entirely destroyed in 1872 by a storm that ripped the roof from the building. A new redbrick building was erected around 1900. History repeated in 2014 during Storm Darwin, when the roof of the club's boathouse was torn off, damaging only one of the boats inside. (Courtesy of the Ludlow family)

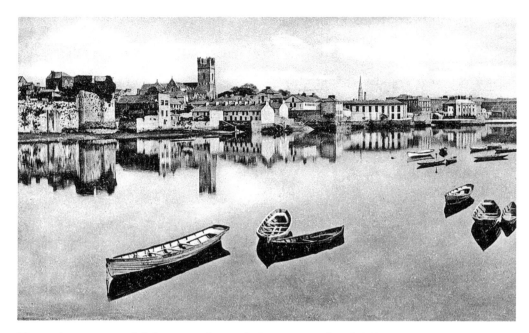

The various groups of fishermen who used the river employed different styles of boats: the casual fisherman, who only fished for sport with a rod and hook, would use angling cots; the Strand fishermen who lived mostly in the Thomondgate area of the city used Gandalows and fished mostly in the estuary using nets; while the Abbey fishermen, who lived in the Abbey and Park areas of the city, used boats called Breacauns and fished-up river with snap nets. All the boats were adapted for different uses on the river; some using oars while others used a pole. (Courtesy of the Ludlow family)

During the First World War, thousands of Limerick men signed up with the Allied forces. The majority of Limerick men signed up with the Royal Munster Fusiliers while the local fishermen enlisted in the navy, putting their skill to use on board the ships. The crew of this naval ship contained at least three members of the Abbey fishermen. (Author's Collection)

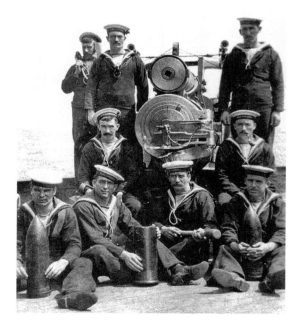

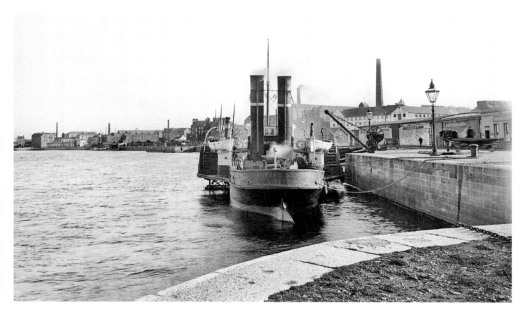

Paddle steamship the *Flying Huntsman* was built in Durham in 1881 for the Clyde Shipping Company, Glasgow. In 1885 it was sold to Sir James Spaight in Limerick before being sold to a number of Waterford companies from 1889 until 1907 when it returned to the hands of a Limerick company. In 1912 it was sold for break-up in France. While owned by a Waterford company the *Huntsman* would dock in Limerick and in July 1897 a regatta was held in Limerick. (Eason Collection, NLI)

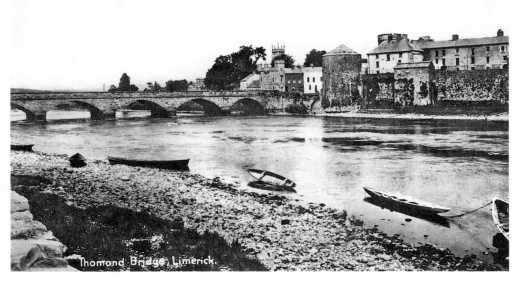

The Shannon River is tidal and as such, it takes skill to know when it is safe to navigate it. These boats rest at Curragower in low tide, tied to each other and the shore, waiting for high tide to return. (Courtesy of the Ludlow family)

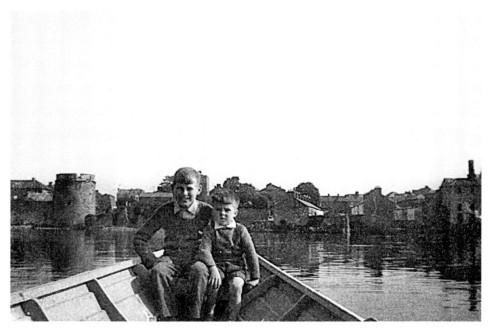

The Slater children came to visit Limerick in the 1960s and, as with tourists today, they stopped by the river to take postcard pictures of themselves on their travels. First in a boat at Curragower, then with the roofless courthouse in the background, at Brown's Quay with St Mary's Park in the background and the iconic picture of the castle. (Author's Collection)

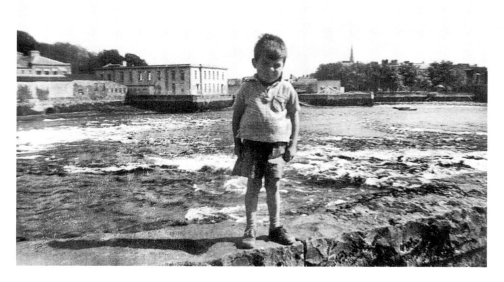

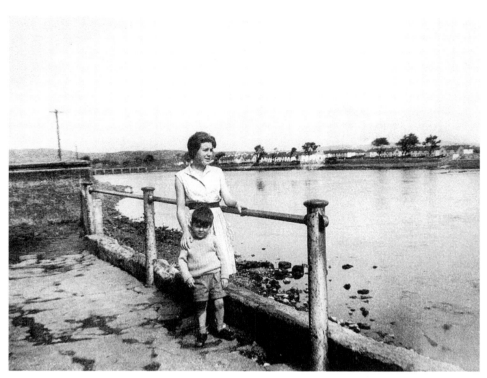

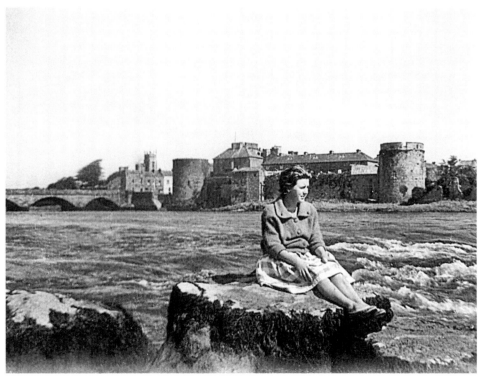

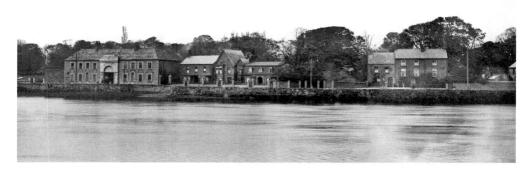

The House of Industry. The large stone building on the left was the first building on the North Strand (Clancy's Strand), erected in 1774 to help with the city's poor. It was built only two years after the legislation was passed to establish poorhouses in Ireland. After a purpose-build workhouse was erected on the Shelbourne Road in 1842 and the poor were moved, this building became the Stand Barracks. The barracks housed members of the British Army and this was ransacked in a series of attacks in the 1920s. It would be used by the city corporation as a depot from the 1930s, before being most recently converted into private apartments. (Courtesy of the Ludlow family)

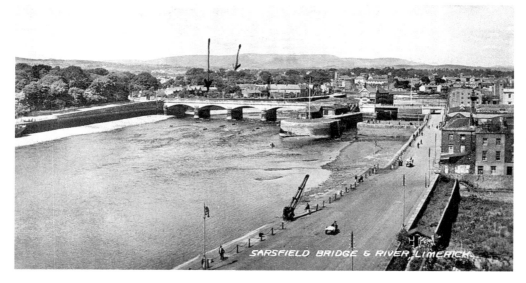

The area in front of Sarsfield Bridge was known as Poor Man's Kilkee. It was a sandy section that would appear when the tide was out and it was used by those who could not afford to take the time off or the train fare to visit the beach as a suitable summer's day paddle. Kilkee, in County Clare, was and still is one of the favourite holiday spots for Limerick residents, with the city becoming quieter during the summer as residents relocate to the seaside. The author Charlotte Brontë stopped in Limerick on her way to Kilkee for her honeymoon in 1854. (Courtesy of the Ludlow family)

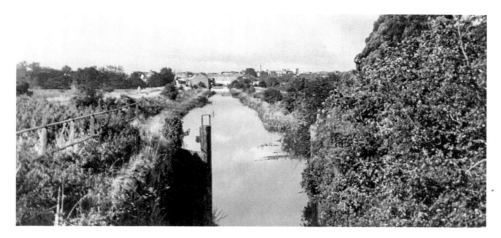

This picture is looking back towards the city from Park Bridge in 1975 and shows the canal in a state of disrepair. Work began on the canal, which linked Limerick to Dublin, in 1757. In 1831 the cost per passenger to O'Briensbridge was twopence. Some 100,000 people per year used this route. It was a four-day trip to Dublin using this route and the passenger boats were known as 'flyboats'. In 1960 the last barge from Dublin travelled down to Limerick and the canal was closed to commercial use. It remained in this state until the 1980s when the Limerick Civic Trust began a series of repairs to the area. (Courtesy of Dan Troy)

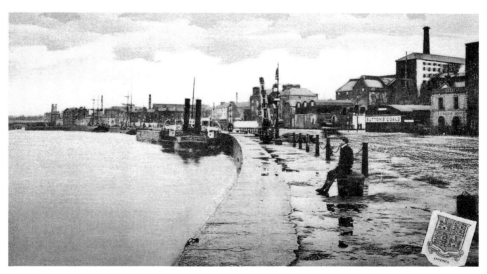

The quays of Newtownpery were built by the large merchant families, the Harveys, Howleys and Fishers. They named the quays after themselves and had moorings outside their warehouses for the loading and unloading of goods. The following list is from the trade directories for Harvey's Quay from 1838 to 1886 and describes other businesses operating in the street: Mr Crilley, baker; John Crilley, spirit merchant; W. Crilly, ship chandlers; J. Ryan, tailor and habit maker; Talbot and Son (Robert and William), block and pump makers (William also operated here as a bicycle and tricycle agent); Eliza Ryan, public house; William Ryan, tailor; Timothy Morrisy, spirit merchant; M. Dawson and Son, iron merchant; James Belle, refreshment rooms. (Author's Collection)

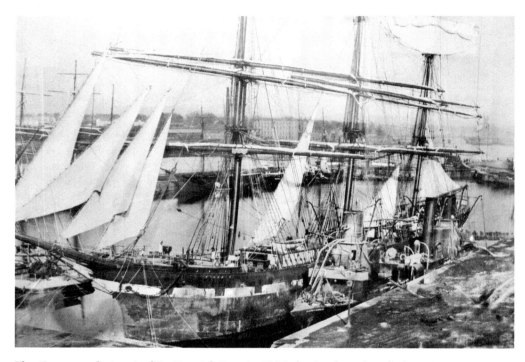

The *Garryowen* first arrived in Limerick Port in 1921, having been bought by J. Bannatyne and Sons Ltd. After 1930, she was owned by Ranks Ireland Ltd. She was a small steamboat, and can be seen here tucked into the quayside beside a larger sailing ship. The *Garryowen* was used by the Ranks from the early 1900s until 1978 when the new entrance to the docks was opened. The Shannon River, which flows through the heart of Limerick, is a tidal river. Twice a day the river level rises and falls, the river is also influenced by seasonal tides. This means that in the summer at low tide it is almost possible to walk across the river floor and during the winter at high tide the river can over flow its banks and cause flooding. (Courtesy of Limerick Museum)

Fishermen were not the only users of the rivers. For generations, families known as 'sandmen' plied their trade along the Shannon River, Abbey River and canal. They used flat-bottomed boats known as sandcots fitted with a winch system to dredge the bottom of these three waterways. The sand was then taken to Sir Harry's Mall (or, as it was commonly known, the Sandmall) in the Abbey area, where it was tipped out to dry. This sand was used in the buildings of Limerick until the 1920s when the Shannon Hydroelectric Scheme put an end to the practice. The families involved, namely the Crowes and the Frawleys, lived in the Abbey area. This couple are pictured outside the Athlunkard Boat Club, *c.* 1900. (Courtesy of the Diocese of Limerick)

The Athlunkard Boat Club is situated on the Abbey River. It was established in 1898 and the first clubhouse was built with voluntary labour in the late summer that year. The following year the club wore blue and crimson at the Limerick Regatta and won the Quin Cup. In 1925 a new two-storey clubhouse was built. The building was damaged by fire in 1995 but funds were raised to repair the damage. (Author's Collection)

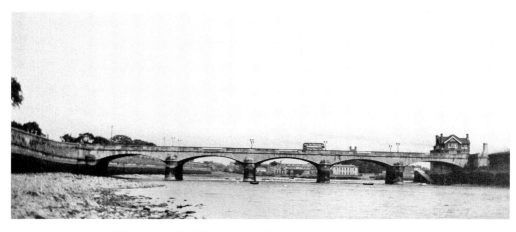

In 1948 several small boats could still be seen on the Shannon as a double-decker bus passes over Sarsfield Bridge. Sarsfield Bridge was officially opened on 5 August 1835 and was based on the Pont de Neuilly in Paris. The bridge took eleven years and almost £90,000 to build. It was designed by a Scottish engineer Alexander Nimmo who had passed away three years before the bridge was completed. The original name of this bridge was Wellesley Bridge, named after Richard Wellesley, a Lord Lieutenant of Ireland from 1821 to 1828 and again from 1833 to 1834. (Courtesy of Yvonne Thompson)

6

STREETS AND SCENERY

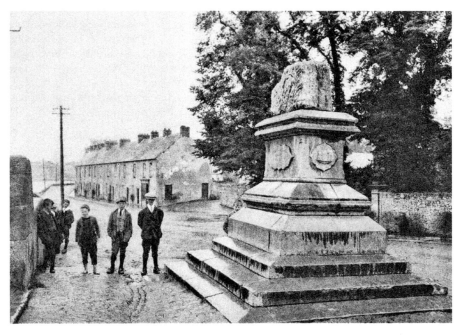

View down Clancy Strand in 1921; at the time it was still known as North Strand. The name was changed to commemorate George Clancy, who, along with Michael O'Callaghan, was murdered on 7 March 1921. Clancy was reigning mayor at the time while O'Callaghan had served the year previous. Clancy, a lifelong republican and member of the Gaelic League, actively encouraged the promotion of the Irish language, both in Dublin (where he worked until 1908) and later in Limerick. He was an influential member of the committee that helped to elect Eamon de Valera at the East Clare by-election of 1917. (Author's Collection)

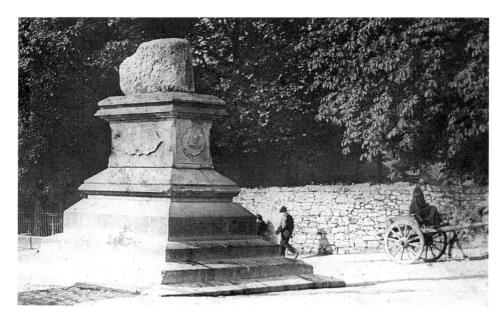

In the 1850s the Treaty Stone was located in front of what is now Jack Mondays and was used as a step to mount horses. In 1863 a fund was started to stop souvenir hunters from eroding the stone. In 1865 it was raised onto a pedestal and moved to the opposite side of the bridge. The pedestal was erected by John Rickard Tinslay, mayor of the city at the time. In 1990 the Treaty Stone was moved further down Clancy Strand in the term of Mayor Gus O'Driscoll as it had become a hazard to road users. Today it is surrounded by informative bronze plaques inserted into the ground at the base of the plinth. (Courtesy of the Ludlow family)

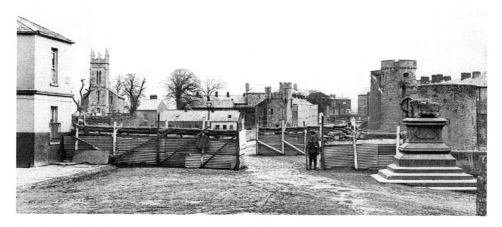

The Limerick Soviet was a unique moment in Limerick city in April of 1919. During a two-week period the city became an independent country, with its own printed money. The Soviet came about as a result of a decree of martial law being placed on the city following the death of Robert Byrne, a trade unionist and IRA volunteer. The Limerick Trades Council of which Byrne was a member arranged a general strike in defiance of the military occupation of the city. (Courtesy of the Ludlow family)

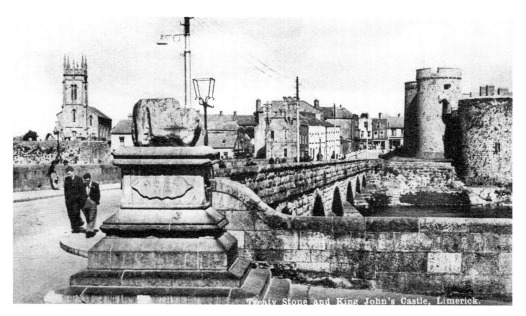

By the 1940s the gas lamps on Thomond Bridge had been replaced by electric lights, though the shell of the gas lamps remain attached to the bridge. (Author's Collection)

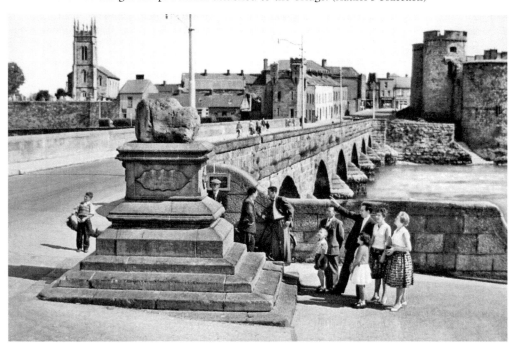

This popular postcard scene shows a tourist view of Limerick, with the Treaty Stone in the foreground, the castle and St Munchin's Church of Ireland church in the background. The houses facing us on Verdant Place are no longer in use and a road had cut through The Parade in the background. (Hinde Collection)

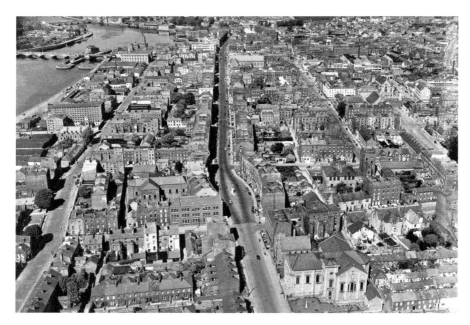

A 1950s aerial view showing the length of O'Connell Street with St Joseph's church in the foreground and Henry Street on the left, running parallel to O'Connell Street. The grid work of the original Georgian city can be clearly seen. In 1769, Edmund Sexton Pery contracted an Irish designer, Christopher Colles, to create plans for a new town on land he owned in the South Liberties. The majority of the city followed this original plan. This area became known as Newtown Pery and is one of the largest examples of Georgian architecture in Ireland. (Author's Collection)

The view down O'Connell Street from the Protestant Young Men's Association building. The streets are lined with people watching the parade of a dignitary through the city, a common sight in the nineteenth and early twentieth century. Often these were dignitaries but they were also the military making their way from one barracks to another. In the 1930s the streets were lined once more, this time for the Grand Prix when international racing car drivers gathered in Limerick to race through the streets. In 1936 the 22-year-old Duke of Grafton was killed and the event was not repeated. (Courtesy of the Ludlow family)

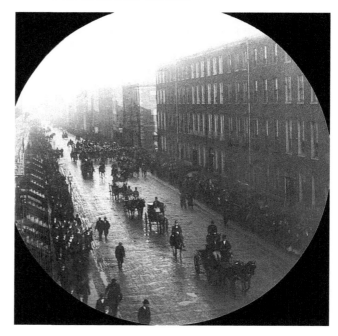

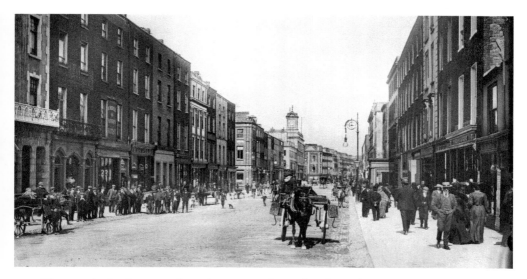

The man in the foreground was known as a 'jarvey' and was driving a 'jaunting car' – these were horse-drawn taxicabs where the passengers faced away from each other. The sixth building in on the left, No. 120 O'Connell Street, was and still is owned by the O'Mahony family, who have run a bookstore in this location since 1902. It was opened by John Patrick O'Mahony who was originally from County Cork. In 1911 he had been married to Marguerite for fourteen years and had five children. (Lawrence Collection, NLI)

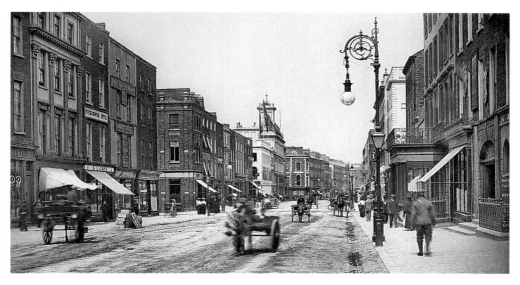

The porch on the right of the picture was the Country Club. It was taken over by the Augustinians in 1946 and is used as their priory. The Augustinians paid £15,000 for the building and the priory was officially opened on 25 May 1948. The original entrance to the Augustinian chapel was through the stone arch on the right of the picture, having moved to this location from Creagh Lane in the late nineteenth century. The Augustinians arrived in Limerick in 1633. An original piece of their old chapel was embedded in this church wall in 1962. (Lawrence Collection, NLI)

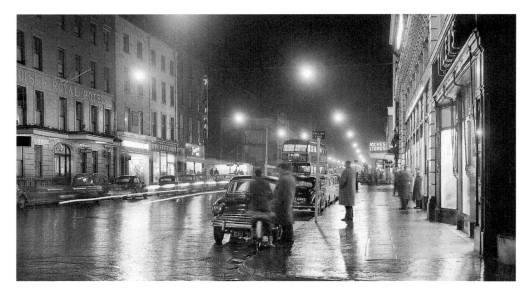

This picture was taken after the Todd's Fire of 1959. The site between William Street and Thomas Street had been cleared to make way for a new building. On the left are Cruise's Royal Hotel, Hipps Men's Tailors, Hassetts' Ironmongers and Saxone Shoes. On the right are, Tylers Shoes, Cannocks Department Store, MacMahon Day Chemists and Roches Stores. The second car on the right, a Morris Minor, was registered to Annie Ryan of Clare Street in 1953. (Courtesy of Sean Curtin)

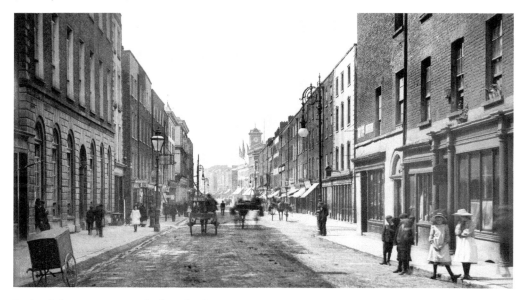

Rutland Street was named after Charles Manners, 4th Duke of Rutland, who was appointed Lord Lieutenant of Ireland in 1784 and who visited Limerick in 1785. He died in office the following year. In 1951 it was proposed by Clann na Poblachta to rename Rutland Street to Daly Street. The motion was not passed. The houses on the right were demolished to make way for the Revenue building, Sarsfield House in the 1970s. (Lawrence Collection, NLI)

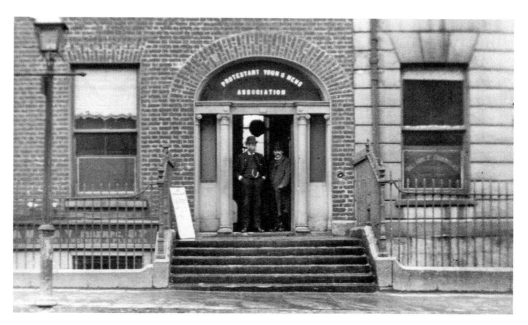

The entrance of the Protestant Young Men's Association, No. 97 O'Connell Street. The Association was founded in Limerick in 1853 and moved to this location in 1875. The caretaker of the building in 1911 was George Miller. He lived in the house with his wife Margaret and their four children. (Courtesy of the Ludlow family)

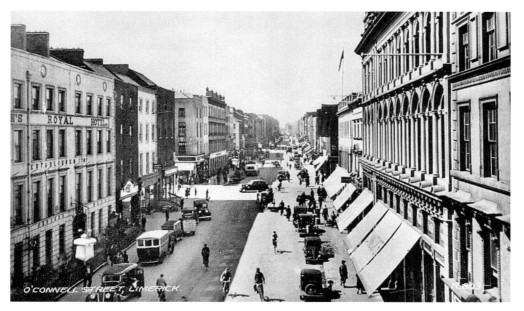

In 1935 cars were starting to take over the main thoroughfares of the city, though bicycles and horse-drawn carts were still prevalent on the streets. At the time, canopies were a prominent feature on shopfronts, blocking both the sun and the rain from the stores. Electric street lights hung from wires between buildings. (Courtesy of Limerick Museum)

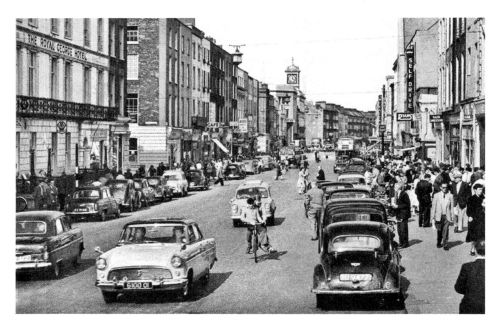

In April 1961 the red-faced manual Cannock's Clock was dismantled and replaced with the black-and-white digital version. In those short years the frontage on the Royal George Hotel changed from a typical Georgian appearance to a bright yellow brick. A television rental company RTV appeared on the streetscape, the first Irish television program was shown on Telefís Éireann on New Year's Eve, 1961 with President Eamon de Valera making an address to the nation. (Hinde Collection)

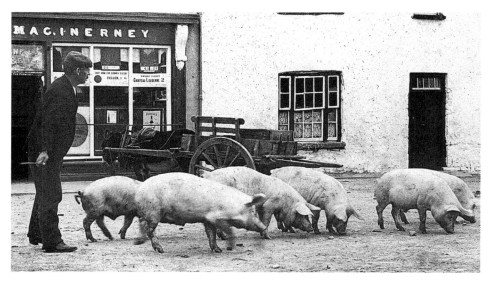

It was a common sight to see pigs marching though the city on their way to one of the many bacon factories. These are on Parnell Street directly across from the railway station, most likely on their way to Matterson's factory, which was located at the top of Roche's Street. (Courtesy of the Ludlow family)

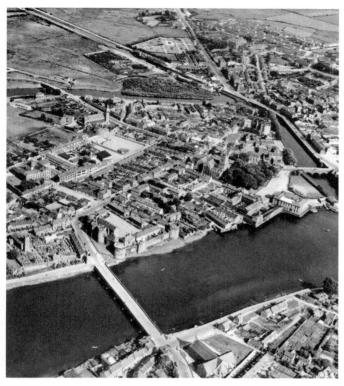

This aerial view from the 1940s shows the newly opened St Mary's church, as well as O'Dwyer's Bridge, built in 1931, linking the city to Corbally in the background. The bridge was dedicated to Dr Edward Thomas O'Dwyer who was consecrated Bishop of Limerick on 29 June 1886. Bishop O'Dwyer stood fiercely against the Irish involvement in the First World War. After vicious mob attacks in Liverpool on a number of Irish emigrants en route to America, the bishop wrote scathingly, 'their crime is that they are not ready to die for England. Why should they? What have they or their forbears got from England, they should die for? It is England's war, not Ireland's.' (Author's Collection)

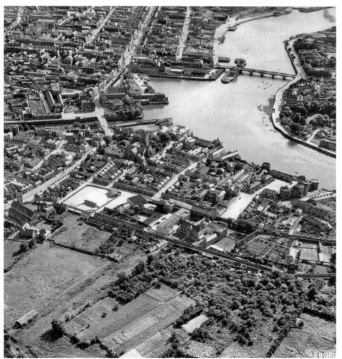

This image shows the edge of the old city wall surrounding the King's Island. The distant line can be seen with farmland to the foreground and the urban area behind what was the walled city. St Mary's church was located outside of the old walls. The farmland was later the site of the Abbeyview, Assumpta Park and Lee Estate housing estates. A river walk circles King's Island, though this was severely damaged during the storms of 2014. (Author's Collection)

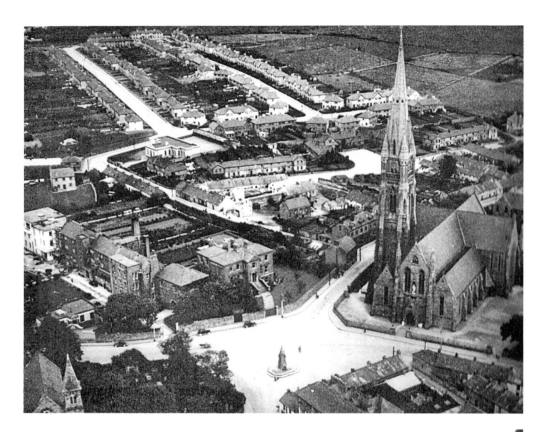

This view of St John's Cathedral shows the early developments in Garryowen in the background. St John's Hospital is to the left of the image. St John's Hospital was founded in 1780 by Lucy Hartstonge, the sister of Edmund Sexton Pery. In 1888 the daily running of the hospital was taken over by the Little Company of Mary Sisters, also known as the Blue Nuns due to their pale blue veils. These Sisters lived on site at the hospital until 1997. (Author's Collection)

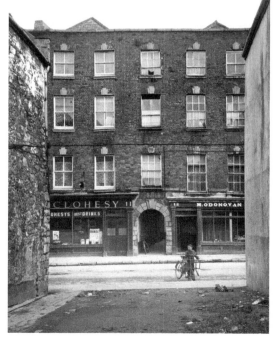

The archway in the centre of this image was known as Campbell's Bow, named after the business that once stood where Clohesy's is in this image. In 1911 there were three houses in this bow, one of which housed five families; George Dillon and his family of seven only had access to one room. (Courtesy of Limerick Museum)

Looking toward St Mary's Cathedral from the tower of St John's Cathedral, this image shows the extremely run down old Irish town area in the mid-twentieth century. St John's Church of Ireland church in the foreground stands on the site of an earlier church in the Irish town area of the city, which dated from the 1200s. It is located at one end of John's Square, the first development of Newtown Pery. The walls around the graveyard were built in 1693 and the present church was built in 1852. The graveyard is the burial place for many well-to-do Limerick families, including the Russells, who ran the largest mills in Limerick in the mid-nineteenth century. The church fell into disuse in the early 1970s as the Anglican population of Limerick city fell and was handed over to the Limerick Corporation in 1975. (Author's Collection)

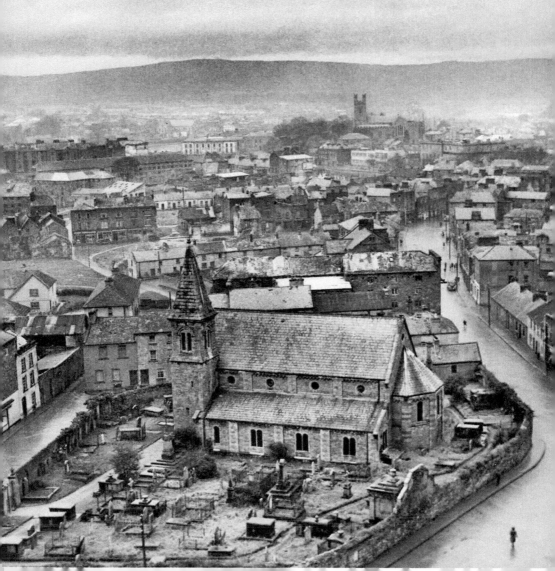

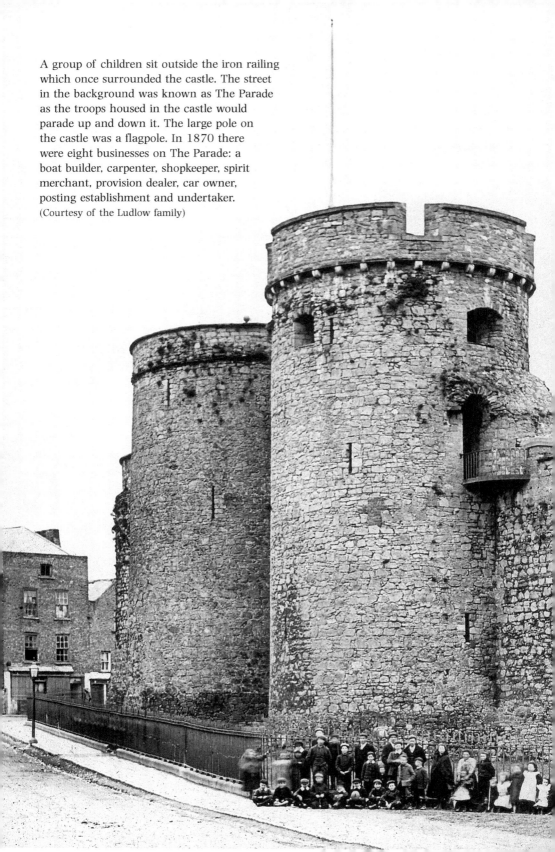

A group of children sit outside the iron railing
which once surrounded the castle. The street
in the background was known as The Parade
as the troops housed in the castle would
parade up and down it. The large pole on
the castle was a flagpole. In 1870 there
were eight businesses on The Parade: a
boat builder, carpenter, shopkeeper, spirit
merchant, provision dealer, car owner,
posting establishment and undertaker.
(Courtesy of the Ludlow family)

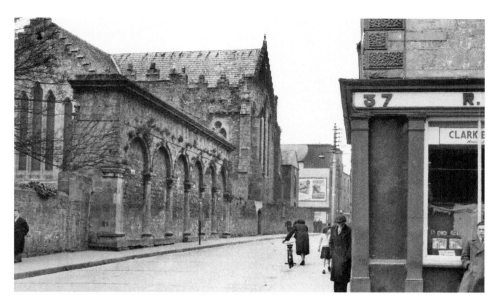

On the left is what remains of the Exchange wall. The Exchange was originally built in 1673 by Mayor York. It was rebuilt in 1702 and again between 1777–78, and forms part of the wall that surrounds Saint Mary's Cathedral graveyard and faces on to Nicholas Street. James Pain was paid £432 17s 5d for repairs and alterations in April 1815, while George Richard Pain carried out further repairs in June 1819 at a cost of £182 1s 2½d. This was the meeting place for the Limerick Corporation before their move to the Town Hall on Rutland Street in 1843. (Courtesy of Limerick Museum)

Nicholas Street has changed a great deal in the past thirty years. The buildings to the left have been demolished and the road has become a one-way street. Nicholas Street was once the busiest street in the city, being one of the main streets in the medieval section of the city leading from the castle to Baal's Bridge. (Courtesy of Limerick Museum)

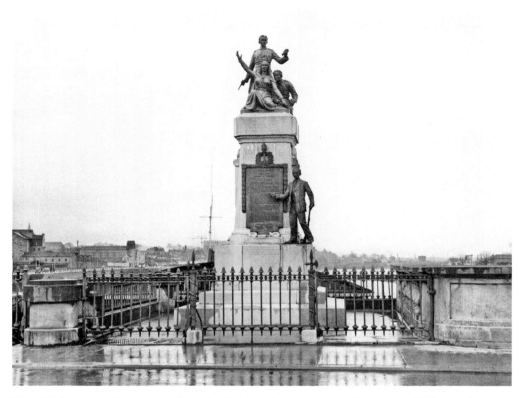

The 1916 memorial was erected on Sarsfield Bridge in 1956 and was unveiled by Madge Daly, sister of Ned Daly and sister-in-law of Thomas Clarke. It contains a bronze figure group depicting Edward Daly and Con Colbert freeing Mother Eire, depicted as a young maiden, from the shackles of oppression. The group stands on a high limestone pedestal with a bronze statue of Tom Clarke pointing to the 1916 Proclamation. Inscribed are the names of the sixteen men who were executed during May 1916, and the names of sixty-five others, killed in action during the same period. (Courtesy of Limerick Museum)

7

CHILDHOOD

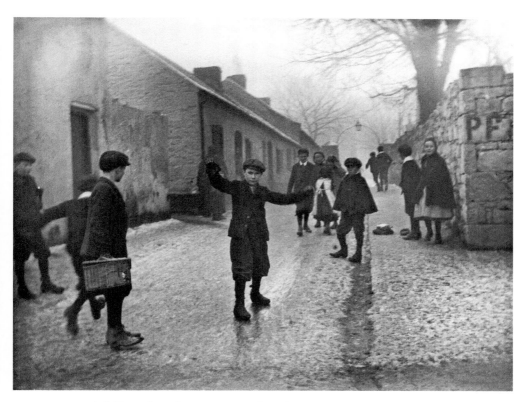

A group of children skate down an icy road in Thomondgate, *c.* 1900. The whitewashed wall on the right was the outside of Walker's distillery in Brown's Quay. Some of the children are wearing caps while others carry wicker baskets. Even though it is the height of winter the boys are all in short pants and long socks. This fashion for short pants on boys continued until the 1960s. (Courtesy of the Ludlow family)

St Michael's Temperance Society ran several carnivals at various venues around the city. This picture was taken at the back of St John's Temperance Society building on Sexton Street. During the 1950s and 1960s this area was used for carnivals and daredevil acts. This area was knocked through to make way for a new road from Sexton Street to Mulgrave Street. The new street was called Sráid An Ceoil/Music Street after the St John's Band who had their band hall in the building. (Courtesy of Sean Curtin)

St Mary's Playground on the Island Road (known as the Tanyard Playground) was opened around 1948 and was the source of great entertainment for the local residents for many years. The building across the way was home to Jim and Laura O'Donovan and their family. Spratt's Shop now occupies the house. It was discontinued as a playground more than 30 years ago and houses were built on the site. (Courtesy of Sean Curtin)

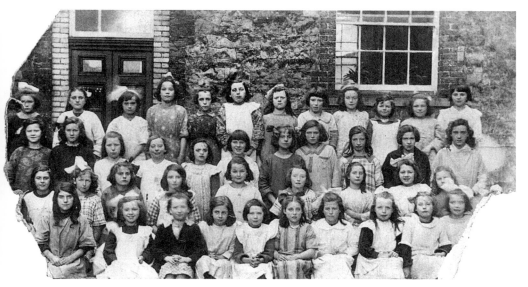

St Mary's Girls School, Bishop Street, *c.* 1920, with Edna Walters sitting in the front row on the far left. (Author's Collection)

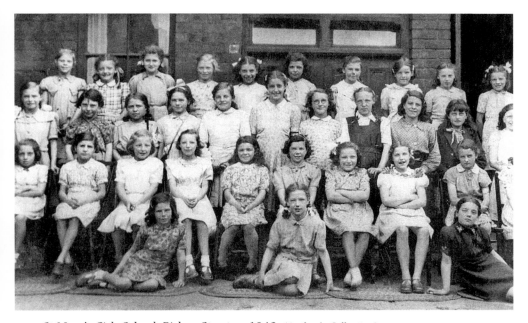

St Mary's Girls School, Bishop Street, *c.* 1942. (Author's Collection)

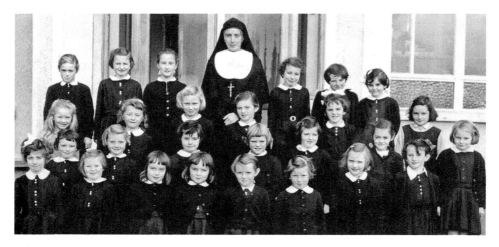

Salesians Convent purchased Fernbank House on 1 September 1924 from the Cleeve family. The following year the gates opened to new pupils. At first the school was a private school and only opened to public students in 1947. The five teachers on the staff were Sr Margaret Lynch, Miss Kitty McCarthy, Miss Kathleen Dignam, Sr Mary Brosnan and Mrs Mary Walsh. The students pictured attended the school about fifteen years later. In 1952 the Intermediate Examinations, a precursor to the Junior Certificate, was added and three years later the secondary school was opened. In 2015 the secondary school was closed with the remaining students transferred to St Nessan's Community School. (Author's Collection)

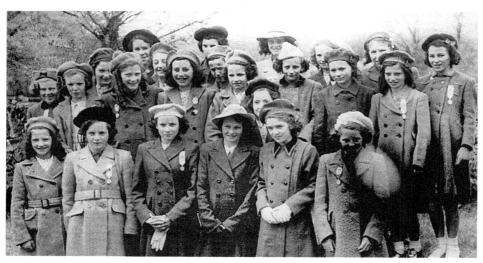

The first school in the parish of St Patrick's opened in the back of the church in 1865. In 1916 a purpose-built school was opened on Dublin Road. As the population in the area grew, a separate boys school was opened across the road in 1966 while the girls remained in the old school. This picture shows the confirmation class of St Patrick's Girls School, Dublin Road in 1946. Included are: Kitty Doyle, Claire Manning, Eily Quilligan, Gertie Kelly, Maire Sheehy, Mary Broe, Maire Quinn, Mary Hannan, Maire Mulqueen, Mary McNamara, Mary Doyle, Martha Murphy, Collette McMahon, Kelly McNamara, Chrissie Lowe, Alice Dawson, Rosy Cunneen, Bernie Nash, Kitty O'Doherty, Rita Cavanagh, Noreen Keyes, Rita Fitzgerald, Peggy Ryan. (Author's Collection)

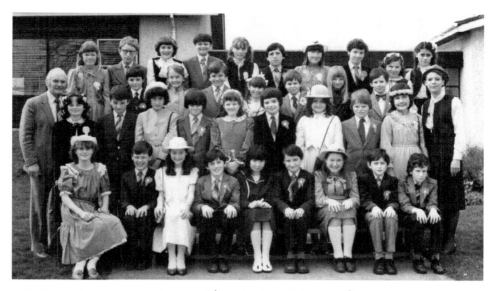

A 1980s confirmation class from Scoil Íde School, Corbally. Scoil Íde, the primary school for the parish of St Nicholas and the surrounding areas, opened in September 1964 with three classrooms and room for 128 pupils. It was run by the Mercy Order for the then parish of St Mary's. As Limerick developed and Corbally experienced a growth in housing developments the school grew to accommodate the local population. Today Scoil Íde has a student population of almost 800 pupils and forty full-time teaching staff. (Courtesy of Scoil Íde)

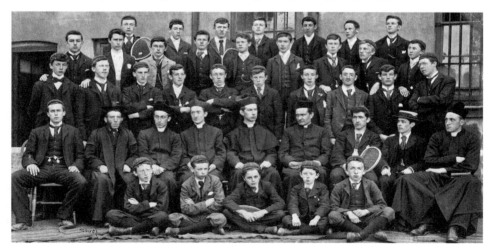

Students and staff of St Munchin's College in 1896–1897. The foundation of St Munchin's College can be traced back to 1796 when the Bishop of Limerick, John Young, set up the Limerick Diocesan College. The college was originally located across the city from Palmerstown, but moved many times, to Newgate Lane, Park House in Corbally, Mallow Street, Hartstonge Street and then Henry Street. Finally, a purpose-built school was erected on the banks of the Shannon in Corbally. The foundation stone was laid on 28 April 1960 by Henry Murphy, Bishop of Limerick. In 2004, the last nineteen boarding pupils left the school and from 2012 until 2015 the school grounds underwent a major redevelopment process. (Courtesy of St Munchin's College)

The students of St Munchin's College in 1935. (Courtesy of St Munchin's College)

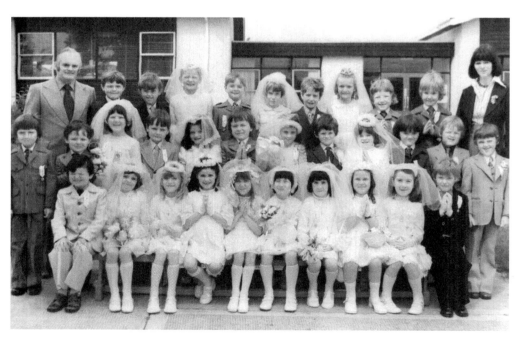

A series of communion classes taken at Scoil Íde from the 1970s to the 1990s. (Courtesy of Scoil Íde)

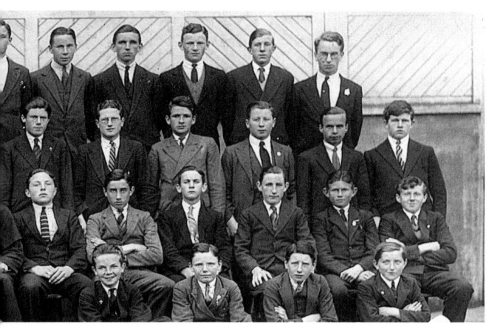

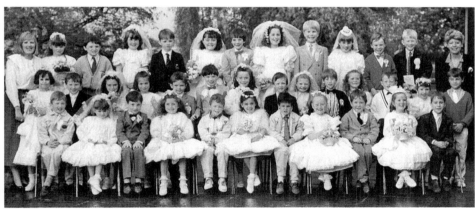

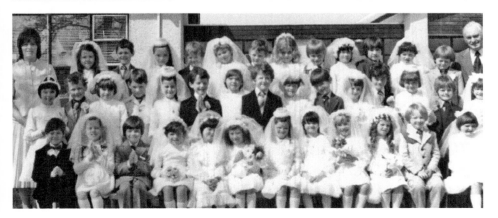

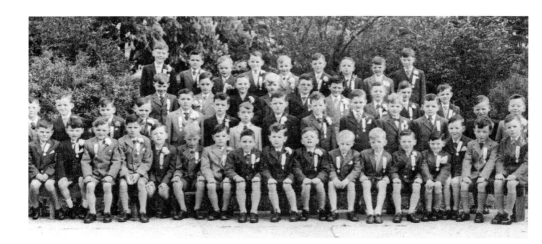

The 1959 class first communion at Janesboro National School, including Kevin Doyle, Eric O'Neill, James Connolly, Mark Liddy, Paddy Hynes, Johnny Halvey, Jim Whelan, Gerard Moore, Pat Ryan, Dermot Heffernan, Michael Casey, Ray Lowe, Eamon O'Flynn, Jim Norris, Peter Clarke, Ger Bugler, Cyril McLoughlin, Martin Kiely, Michael Henry, Pat Tobin, Patrick Harris, Noel Purcill, Paddy Bannon. (Courtesy of Martin Kiely)

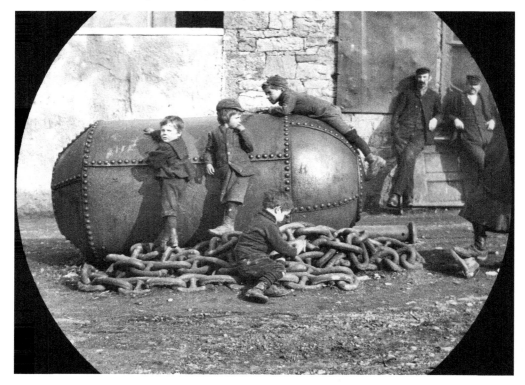

At the turn of the last century the entire city was a playground. These young boys make use of the objects left in the docks while waiting for their families. The water's edge was a very dangerous playground and drowning accidents were commonplace. (Courtesy of the Ludlow family)

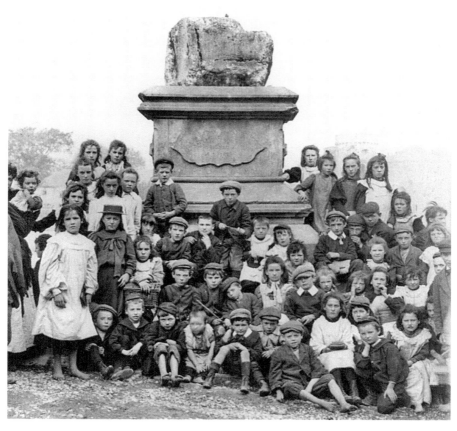

This 1903 image of children at the Treaty Stone show many of them barefooted and some carrying books. Children did not necessarily go barefoot due to a lack of shoes; occasionally the shoes were discarded at home as they were made with stiff leather and could be uncomfortable to wear. (Courtesy of the Library of Congress)

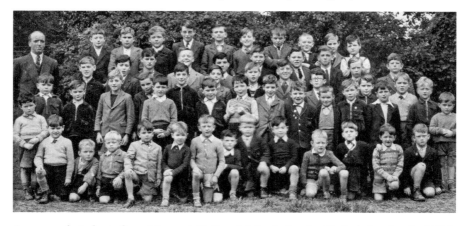

A group of students from Mungret National School stand with their teacher in 1956. (Courtesy of Reg Morrow)

In 1982 the Kirby Cup was given to St Mary's Convent School by Christopher (Noel) Kirby. In this photograph, Sister Laboure (principal) accepts the cup, given in recognition of the education given to his five daughters: Teresa, Sylvia, Ann, Susan, Carrie. It was awarded annually to students exceptional in sports, whose names were inscribed on the cup. Thirty years later Ann Nolan Kirby held the cup at a school reunion. (Courtesy of Ann Nolan Kirby)

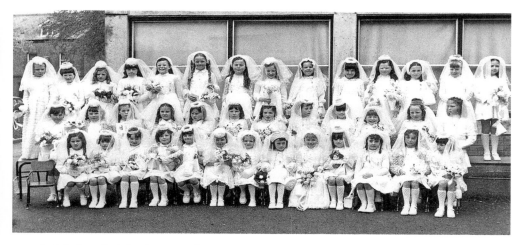

St John's Girls School, First Holy Communion, May 1977. Back row, from left to right: Sheila Quinn, Annette Prenderville, Deirdre Hegarty, Denis Stack, Christine Kirwin, Emily Kearns, Amanda Finnin, Gillian Kirwin, Karen O'Connell, Marion Broe, Ruth McCarthy, Catherine Crawford, Margart Fylan, Sinead Daly. Middle row: Deborah O'Shea, Sandra Barry, Martina O'Donovan, Noreen O'Dwyer, Christine Howard, Kathleen Moloney, Christine Sheehan, Fiona McMahon, Mary Kenneally, Noelle Carr, Colette Hughes, Joan Fleming. Front row: Jennifer Lee, Marlon Kiely, Madeleine Daly, Vera Coughlan, Veronica Hogan, Emily O'Halloran, Margaret Sheehan, Irene Murphy, Karen Waters, Valerie O'Neill, Jacqueline O'Neill, Susan Sheehan, Valerine Madden. (Courtesy of Emily Kearns)

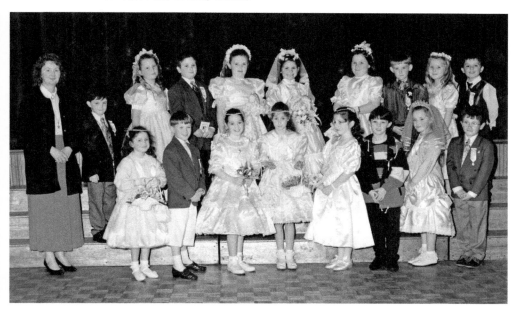

Presentation, Sexton Street, communion class of 1994. From left to right, back row: Mrs Moynahin, Sean Finnin, Alison O'Connor, Damien Rice, Carrie Collins. Andrea Mason, Eileen McMahon, Andrew Wilson, Aine O'Keiff, Owen Walsh, Carol Coyle, Dean Earls, Stacey McQuanne, Thelma Kirwin, Ciera Hayes, Alan unknown, Martina Kiely, Joseph Rooney. (Courtesy of Martin Kiely)

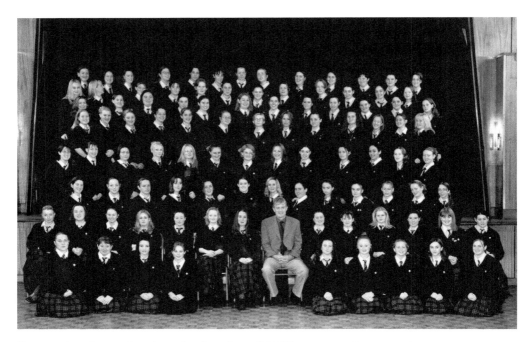

Presentation, Sexton Street, graduation class of 1997. (Courtesy of Martin Kiely)

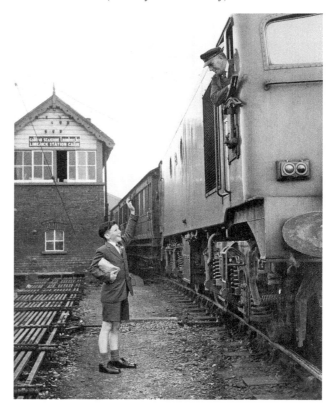

At 8 a.m. on 13 June 1961, Noel Ryan from St Munchin's Boys National School greets the driver of the diesel trail, Mr N. Dunne, at Limerick Station before the fourth class educational tour to Dublin. (Courtesy of Limerick Museum)

8

RELIGION

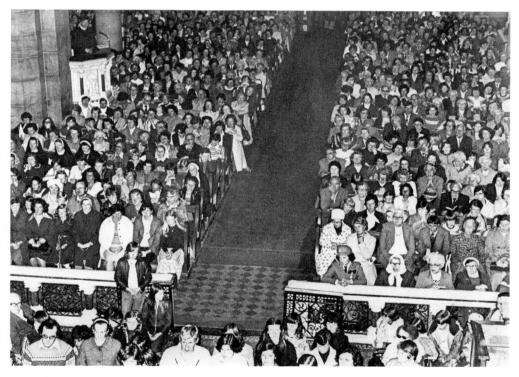

The Solemn Novena in honour of Our Lady of Perpetual Succour in the Redemptorists has been held in Limerick for many years past. The picture on this page comes from around the mid-1970s, when the sessions would be so packed that the entire altar would be full as well as a marquee in the grounds of the church. While there is no marquee these days, the Novena still attracts huge numbers to the Redemptorists year on year. In 2016 Fr Adrian Egan told the congregation that the Novena is still one of the great occasions in the Church calendar in Limerick. (Courtesy of Sean Curtin)

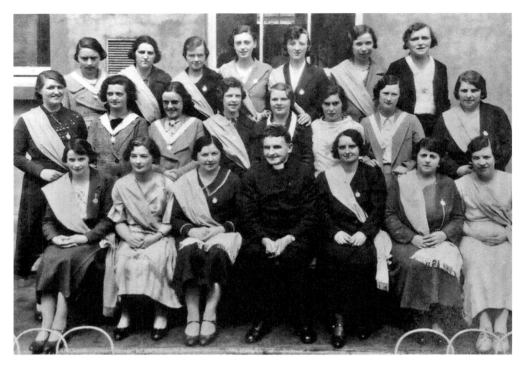

Two pictures of the Legion of Mary in Limerick decades apart, both including Rita Jones (*née* Walsh). The Legion of Mary is a lay apostolic association of Catholics. The first meeting of the Legion of Mary took place in Myra House, Francis Street, Dublin, Ireland, on 7 September 1921. The first Limerick branch began in 1932. By 1961 there were Legion of Mary branches in Newcastlewest, Rathkeale, Athea, Drumcollogher, Broadford, Grange, Adare and Templeglantine with a total of 900 members. (Courtesy of Donal McCormac)

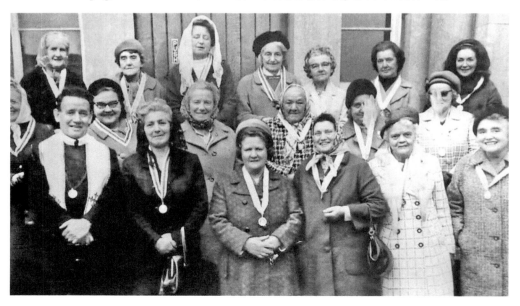

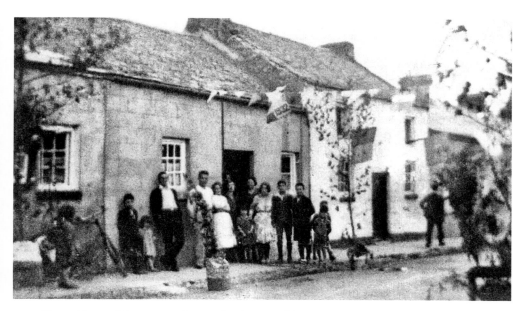

The residents of Quarry Road erected a shrine and bunting for the Eucharist Congress of 1932. In the pictures are the Walters and McInerney families. The 31st International Eucharistic Congress, held in Dublin in June 1932, marked the 1500th anniversary of the arrival of St Patrick to Ireland. The first Eucharistic Congress was held in 1881 under Pope Leo XIII. Forty-eight congresses have been organised by the Papal Committee for Eucharistic Congresses to increase devotion to the Eucharist as a part of the practice of faith, and as a public witness of faith to society at large. (Author's Collection)

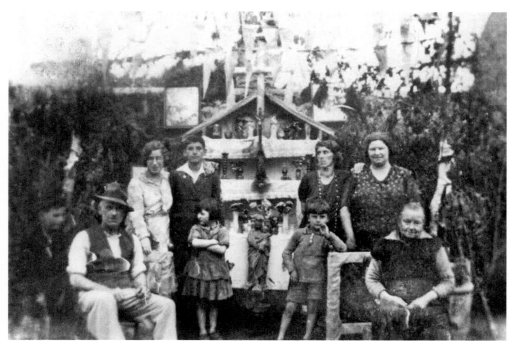

When new housing estates were opened they were blessed by the local priest. The Island Field Housing Estate was opened on 30 May 1935 by Minister Sean T. O'Kelly, who was the minister for Health and Local Government at the time, and Mayor James Casey. It was blessed by Revd Michael Cannon, parish priest of St Mary's church.
(Courtesy of Limerick Museum)

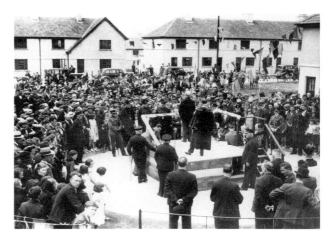

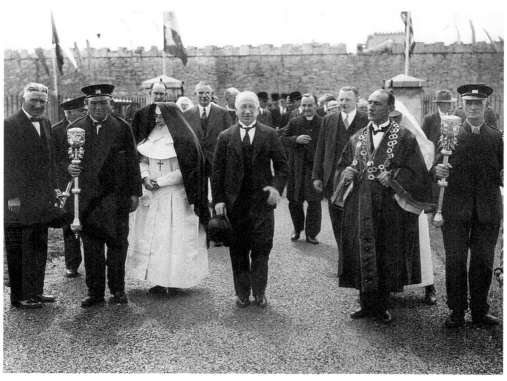

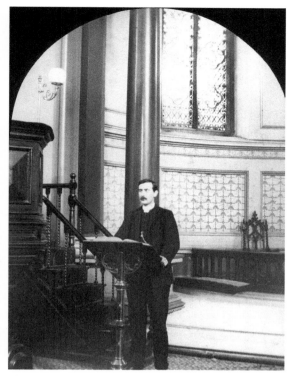

Reverend John Thomas Waller at the pulpit of Trinity church, Catherine Street. He retired from ministry in 1951, aged 86 years. He was a direct descendant of Sir Hardness Waller, one of the judges who signed the death warrant of King Charles I. Trinity church, which is integrated into the streetscape of Catherine Street, was an Episcopal church built in 1834 through subscriptions raised by the Reverend Edward Newenham Hoare. Reverend Hoare was born in Limerick in 1802 and died in Upper Norwood, in London, 1877. (Courtesy of the Ludlow family)

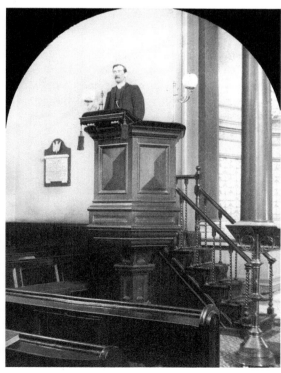

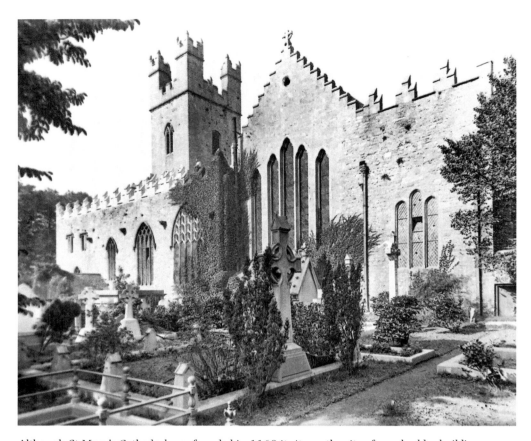

Although St Mary's Cathedral was founded in 1168 it sits on the site of much older buildings. It was the palace of the King of Munster, Donal Mor O'Brien, who donated the land to the Church. Before the land was the seat of the King of Munster it was the meeting house for the Viking city. The Vikings had arrived in Limerick in the ninth century and quickly developed a city. They ruled for over a hundred years until the last Viking king in Limerick, Ivar, was defeated by the Irish royal family the Dál gCais, who served Brian Boru as their king. (Lawrence Collection, NLI)

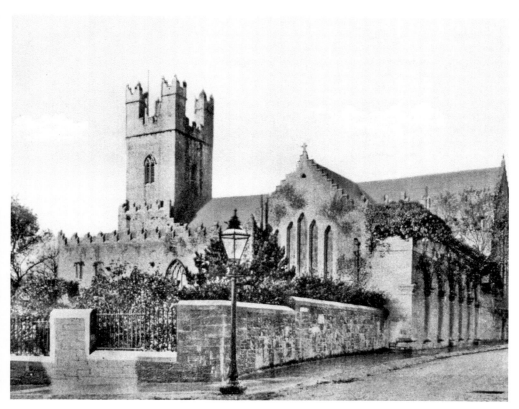

In 1651, after Cromwell's forces captured the city, the cathedral was used as a stable by the Parliamentarian army. Luckily the cathedral survived this relatively unscathed. It is one of the oldest buildings in the city and the oldest still used for its intended purpose. The graveyard contains many interesting plots, including the Roman Catholic graves of Shanny, Clancy and Hayes, who were fishermen in the Abbey Area. Folklore tells us that the Clancys were bequeath their plot by Donal Mor O'Brien himself as they were the family Brehon (lawyers) to the O'Brien's. It is unknown how the Shannys also retained their plot. (Author's Collection)

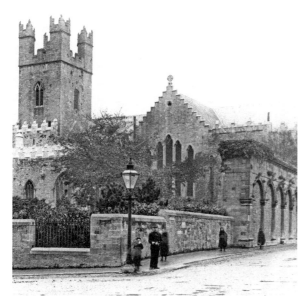

The legend of the bells of St Mary's Cathedral states that they were originally brought from Italy. They had been manufactured by a young Italian and finished after the toil of many years. He prided himself upon his work and sold the bells to an Italian monastery but the monastery was soon razed to the ground and the bells were carried away to a foreign land. The bell-founder became a wanderer over Europe. His hair grew grey and his heart withered. After years of wandering, he sailed for Ireland and proceeded up the Shannon. He hired a small boat for the purpose of landing and sat in the stern, looking fondly towards the cathedral. Suddenly, amid the general stillness, a bell rang the Angelus from the cathedral towers. When the rowers looked round they beheld the bell-founder with his face still turned back towards the cathedral, but the joy of discovering his long-lost bells had killed him. (Courtesy of the Ludlow family)

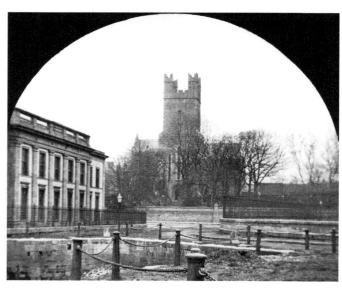

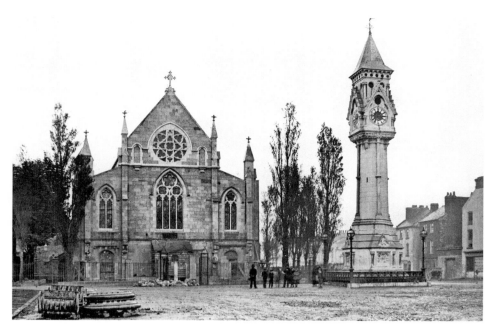

The St Saviour's Dominican present-day church was built when the Dominicans moved from Fish Lane. Edward Henry, the Earl of Limerick, donated the land to the Dominicans. The original church here was a plain church and it gave the impression of Gothic architecture. The church was designed by the Pain Brothers. The foundation stone of the church was laid on 27 March 1815 in the presence of Dr Tuohy, Bishop of Limerick, and the Father Provincial of the Dominicans, Patrick Gibbons. The architect, John Wallace, renovated the church in the 1860s. A clerestory was added, raising the height of the church by 20 feet. The church is dedicated to the Most Holy Saviour Transfigured. (Underwood Collection)

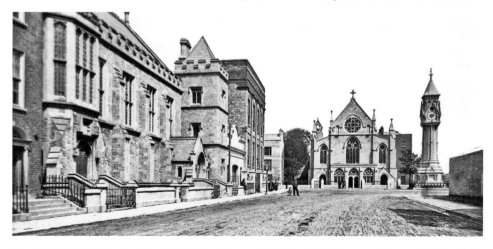

The Gothic building to the left is the former Protestant Orphanage. It was designed by William Fogerty and was built in 1856. The charity was set up in 1833 to provide diet, lodging, clothing and scriptural education for destitute orphans of Protestant parents. The building was later occupied by the Mid-Western Health Board. (Lawrence Collection, NLI)

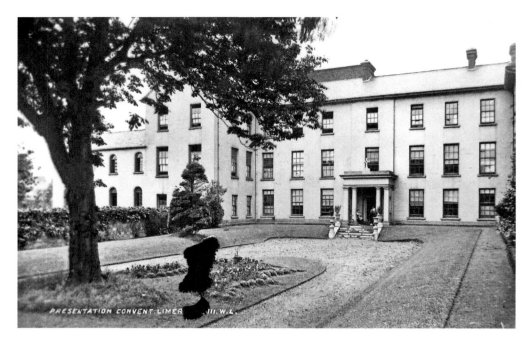

The Presentation Sisters were founded in Cork by Nano (Honoria) Nagle in 1775. On 8 May 1837, three Sisters arrived in Limerick from Cork city. Three weeks later, on 29 May, the Sisters opened a school. In the census of 1841 it was recorded that 41 per cent of the population of Limerick could not read or write. By the end of their first year the Presentation Sisters were supplying 'religious and moral education, reading, writing, arithmetic and useful work for some 340 pupils'. The school is still in operation today at Sexton Street. (Lawrence Collection, NLI)

Laurel Hill Convent was founded in Limerick in 1844 when the Bishop of Limerick invited Marie Madeleine d'Houet, the foundress of the Faithful Companions of Jesus, to open a school. The following year she purchased Laurel Hill and the school opened with thirty-three day pupils and eleven boarders. Former pupils of the school include singer Dolores O'Riordan of the Cranberries and author Kate O'Brien. When Kate O'Brien arrived at the school aged only 6, following the death of her mother, she became the youngest boarder in the school. (Lawrence Collection, NLI)

This illustration shows a very different idea of what the tower of St John's Cathedral would look like. (Courtesy of *London Illustrated News*)

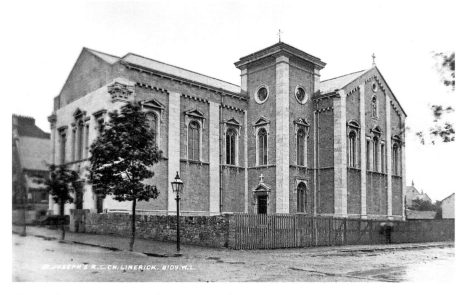

The site for St Joseph's church on O'Connell Avenue was donated by a Mr Byrnes and it was built by John Ryan & Sons in 1904. The building was designed by William Edward Corbett, who was also involved with the design of the nearby Sacred Heart church in the Crescent. The Sacred Heart church was run by the Jesuit order and they operated a system by which the wealthier members of the congregation sat nearer the altar while the poorer classes sat at the back. St Joseph's became known as 'the church of the spite' as it was erected to counteract this practice within the community. (Lawrence Collection, NLI)

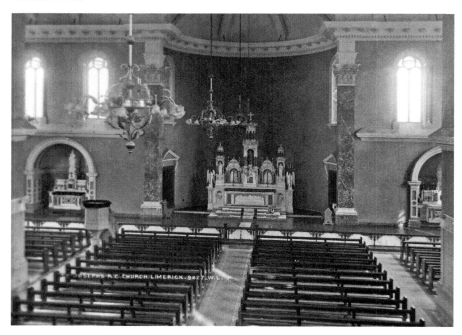

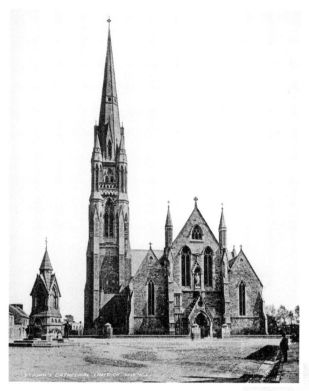

The Cathedral of St John the Baptist is the present-day cathedral in Limerick city and was built in 1856. The chapel which this replaced was founded in 1753. The link between St John the Baptist and the area around the cathedral is long-standing. According to Begley, the Knights Templars had a house in the area in the twelfth century that was dedicated to John the Baptist. The cathedral was designed by Philip Charles Hardwick, who was also working on Adare Manor at the time. Seventeen years after its opening, work began on the spire. Designed by Hennessy's of Limerick, the spire is the tallest in Ireland. The bell in the steeple was carried to Limerick from Dublin by barge, using the canal system. (Courtesy of Limerick Museum)

Mount Saint Alphonsus is also known as the Redemtorist. Having operated out of a temporary church structure since 1854, the foundation stone for the new church was laid by Bishop Ryan on 22 May 1858. His successor, Bishop Butler, dedicated the completed church in December 1862. This view of the church down Quin Street was a hand-tinted postcard showing redbrick instead of grey limestone. (Author's Collection)

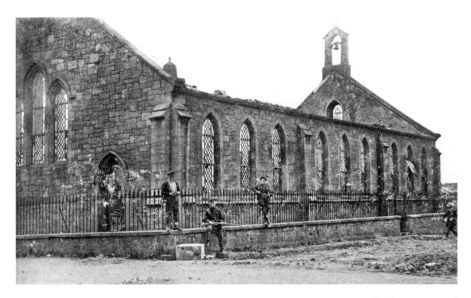

On the days between 11 and 22 July 1922, Civil War tore through the streets of Limerick. At the end of this eleven-day siege a number of people were killed or injured. This period was to become known as the Fall of Limerick. The Republicans set the Artillery (also called the ordnance barracks), castle barracks and New Barracks, now known as Sarsfield Barracks, and the church on fire. (Courtesy of the Ludlow family)

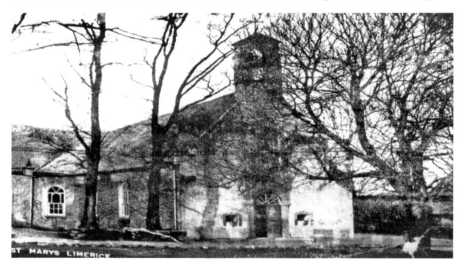

St Mary's Roman Catholic church, as we know it today, was opened in 1932. It is located on Athlunkard Street. It replaced a previous chapel that had stood in this spot since 1748, having its first Mass read on 10 December 1749. All that remains of the original eighteenth-century church is the holy water font at the rear of the new church. This land was originally rented from Alderman Ingrim and replaced a rented Malt House that had been used by the local parishioners for worship. The new church was designed by Ashlin & Coleman of Dublin at a cost of £40,000. The foundation stone was laid on 11 May 1930 by the Bishop of Limerick and the first Mass took place in 1932. (Author's Collection)

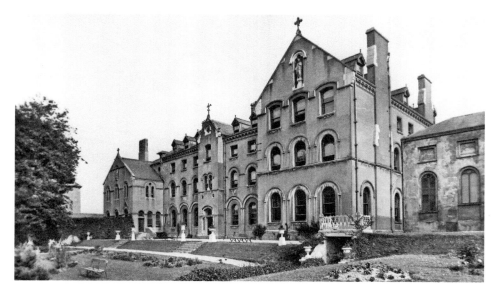

The Good Shepherd Convent was built on the site of an older Lancastrian school, which used older students to teach younger student spelling and reading. The land was taken over by the Christian Brothers and later by the Good Shepherd Convent. In 1994 the building was sold to the Regional Technical College, which is now known as the Limerick School of Art and Design. To the rear of the site was Farrancroghy, which was used as an execution site in the sixteenth and seventeenth centuries. (Lawrence Collection, NLI)

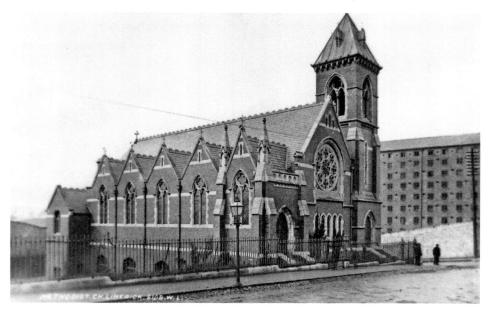

This Presbyterian church on Henry Street was built in 1901 to take over from the Presbyterian church on Glentworth Street. This building is no longer in religious use; the community merged with the Methodist community and relocated their church to Christ Church on O'Connell Street in the early 1970s. It is in use today as an office space. (Lawrence Collection, NLI)

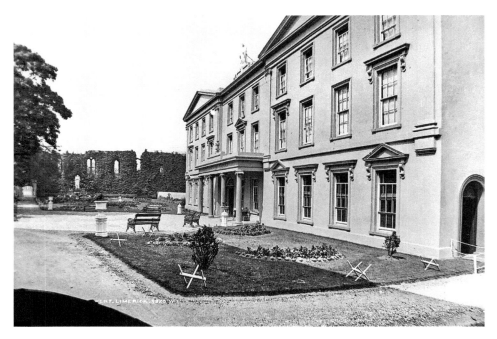

In 1858 Catherine McAuley established the Mercy Sisters in Limerick at the Poor Clare Convent in Limerick. They were welcomed by two surviving Poor Clare sisters who had remained on in Limerick after the departure of their companions eight years previously and who soon were affiliated to the Mercy Congregation. Henceforth, the convent would be called 'St Mary's'. The convent was demolished in 1995. (Lawrence Collection, NLI)

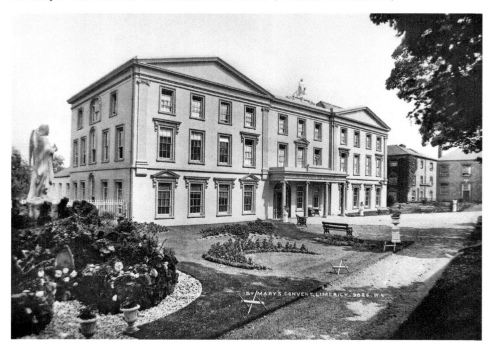

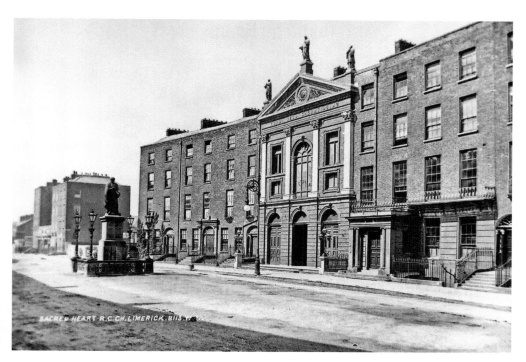

Sacred Heart church was completed in 1868 and opened for public worship on 27 January 1869. The architect was William Corbett and the church is in the parish of St Joseph's. According to some reports, it was originally intended to be dedicated to St Aloysius but when it was formally dedicated in 1869 it was called the church of the Sacred Heart. The façade of the church is Classical/Grecian in design and was renovated in 1900. The Jesuits closed the doors on this building in 2006 and the site was later sold to a private investor. In 2012 the church once again returned to the hands of a religious order. (Lawrence Collection, NLI)

Also from The History Press